COMMUNICATING WITH
ROUGH VISUALS

ALAN SWANN

COMMUNICATING WITH
ROUGH VISUALS

ALAN SWANN

PHAIDON · OXFORD

A QUARTO BOOK

Published by Phaidon Press Limited
Musterlin House
Jordan Hill Road
Oxford OX2 8DP

First published 1989
Copyright © 1989 Quarto Publishing plc

A CIP catalogue record for this book is available from
the British Library.

ISBN 0-7148-2598-0

This book was designed and produced by
Quarto Publishing plc
The Old Brewery, 6 Blundell Street,
London N7 9BH

Senior Editor Susanna Clarke

Editor Lydia Darbyshire

Designer Alan Swann
Picture Researcher Sandra Bissoon
Illustrator John Scorey
Photographer Paul Forrester

Art Director Moira Clinch
Editorial Director Carolyn King

Typeset by Ampersand Typesetting (Bournemouth) Ltd
Manufactured in Hong Kong by
Regent Publishing Services Ltd
Printed by Leefung-Asco Printers Ltd, Hong Kong

Special thanks to Brian Webb of Trickett and Webb,
Croydon College Faculty of Art and Design and
to Paul Diner.

CONTENTS

6 INTRODUCTION

■ SECTION ONE:

8 How to use this book
10 Materials: surfaces
12 How to use the materials
16 Using and controlling markers
18 Other visualization media
20 Overlays of tone and colour
22 Drawing up the shapes for your rough visuals
24 Making initial thumbnail sketches using markers
26 Introducing colour scamps in markers
28 Indicating lettering in your scamps
30 Indicating type in your scamps
32 Rendering lettering: on tracing paper
34 Rendering lettering: on roughs
36 Imaginative lettering
38 Rendering lettering and type with colour
40 Rendering black and white photographs using markers
42 Rendering photographs in colour
44 Rendering illustrations in rough form
46 Marker roughs: visuals of type and photographs
48 Working up your visual using type and photographs
50 Marker roughs: visuals of type and illustrations
52 Working up your visual using type and illustrations
54 Alternative layouts
56 Alternative layouts using other media
58 Stages of presentation: scamp selection to roughs
60 Finished rough visual
62 Rough visuals to artwork
66 Colour visuals and print

■ SECTION TWO:

70 Techniques of visualization
72 Advertising visualization
82 Packaging visuals
90 General design visualization
104 Visualizing illustrations

■ SECTION THREE:

108 Professional visualization
138 GLOSSARY
141 INDEX
144 ACKNOWLEDGEMENTS

INTRODUCTION

OVER THE YEARS, graphic design, as a specialized and professional industry, has achieved excellence through the collaboration of many individual talents.

It is expected that good graphic design is produced through a number of clearly defined processes. These processes start with an initial idea that is suitable for the project in question. The idea is created by the designer or the design team and is based on a client's requirements. At this initial stage the idea will be represented visually as an embryonic version of what is to be developed. From this point on the expertise of many individuals will be called upon. The first of these individuals is the professional visualizer.

This book analyses and explores in depth the skills, methods and processes employed by the visualizer.

To understand the role of the visualizer you must first understand something of the nature of the person fulfilling the role. Unlike the designer, whose job is to solve problems and create concepts, the visualizer enjoys the process of exploring the idea or concept with his visual box of tricks.

THE VISUALIZER

The function of the visualizer is to give visual form to an initial idea through making a variety of choices. These choices would be expressed through the individual emphasis given to each of the elements of the design as well as through the method and medium chosen by the visualizer to express his interpretations. The task is to convey the concept to the client, giving as many exciting alternatives as possible to the commissioned work. In the process of visualization certain stages have become accepted and recognized as the procedures in the development of design ideas. These stages are, first, a drafted idea, which could take the form of written notes or a simple, quick visual notation. The next step is to define the elements required for the design. The space and shape to be used for these elements would be arrived at by the production of thumbnail sketches, which would form the basis for rough visuals, which would, in turn, give shape, form and colour to the idea. They must be the embodiment of the idea in rough form, but echoing the visual presence of a printed piece of work. There is a further stage, which is often used to consolidate and visually convince the client, and this is known as a finished rough.

This book deals specifically with the creation of rough visuals from graphic design concepts.

BASIC REQUIREMENTS

Before attempting to set out a design, a full understanding of the images you will be likely to use is vital. The design will require a knowledge of typefaces that are appropriate; photographic imagery and illustrations that are complementary; and colour that expresses and conveys the mood, tone and ambience that suit the design.

The second requirement is the ability to convey these images with confidence and conviction in a brief but precise manner. This means that to

visualize successfully, skills must be developed. These skills are simply a basic ability to create technically competent drawings with an understanding of, and familiarity with, the media used in this process.

The activity of turning graphic design concepts into rough visuals is by no means a menial and unvalued area of work. On the contrary, it is one of the most prized and highly paid jobs within the graphic design industry. It takes flair, enthusiasm, skill and craftsmanship to produce good rough visuals that communicate graphic design ideas.

PLANNING FOR WORK

A major factor in successful visualization is having the best environment in which to create your work, enough space to lay out and display the tools required and a planned approach to the job to be undertaken. It is obvious that you will need a good surface to work on. I prefer to have a board that is slightly tilted on a flat table or desk. This enables me to surround myself with various coloured pens and the instruments I will need.

You will need to light the working surface, and I would suggest an angle-poise lamp on either side of the work surface to eliminate any shadows that may obscure the work. Your chair should allow you sufficient freedom for your arms to move swiftly and without inhibition.

A number of items and materials will be essential in creating your work. Foremost of these are good layout pads. These are specialist pads that enable you to use marker pens freely and expressively and also allow you to overlay sheets for redrawing and

improvement. Marker pens themselves are numerous in make and quality. There are two different kinds of marker – spirit-based and water-based. The spirit-based markers offer much more scope and variety of image and mark, and I recommend them as your first choice. In the more expensive ranges, the colours available are more extensive and subtle in quality, and there are even some branded markers that link to the actual colours that can be produced by your printer. This is an important consideration when you are producing work for reproduction in print.

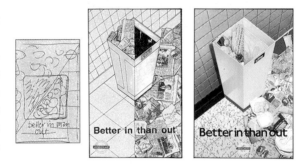

The illustrations shown above identify the three major stages of a design's evolution. The first of these shows the initial scamp. This was prepared in seconds although the idea may have taken several days to develop. The second stage shows the rough visual. This was produced in between two and three hours. Finally, you can see the printed image.

HOW TO USE THIS BOOK

THIS BOOK CONTAINS all the information you will need to help you in the process of creating rough visuals. It is divided into three sections. The first of these describes the materials and media you will require and then demonstrates exercises and experiments in the use of these materials and media. This section gradually introduces you to the skills you will require to carry out the visualization process in a wide range of different applications.

The second section applies the skills and techniques learnt to an actual concept and design brief. This section demonstrates the versatility of visualization through a number of illustrated examples of different areas of design work.

The third and final section allows you to compare some initial roughs with the finished printed pieces. These have been extracted from some of the top design studios and are good examples of what is currently required by the clients of the graphic design industry.

SECTION ONE

MATERIALS: TOOLS

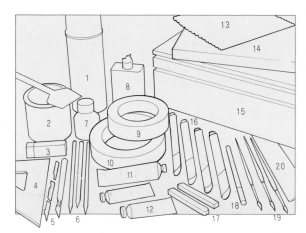

*PANTONE, Inc.'s check-standard trademark for color reproduction and color reproduction materials.

Before starting work you will need to equip yourself for the tasks ahead. A number of primary requirements are standard for the designer's/visualizer's function. Some of these items will be used in the production of every job; others you will need to have available only for the more specialist task.

I will deal first with the most essential items. You will need a good range of soft and hard pencils; a range of black fine liner pens; a set of fine sable brushes; a craft knife with changeable blades; scissors; a soft eraser; a ruler; compasses; set squares; designers' black and white gouache; a white pencil; a range of coloured pencils; a range of quality markers; a drawing board. You will also need masking tape and sellotape as well as a spray glue for mounting your work.

Naturally, the markers are going to be the key instruments in the production of your work. There are many ranges of marker available, but most professionals find that only two brands are of a high enough standard and give a full range of colours. I therefore first recommend PANTONE®* markers. These are available in a fine nib and a broad nib, and their special quality is the potential for the printer to reproduce the actual colour you have shown in your visual. These markers are used by professional studios involved in the production of printed work.

My next choice is Magic Markers. These come only with a broad nib, but this nib is tooled in such a way as to give great flexibility of both line and mark. There is a good choice of colours, and these markers are preferred by the advertising visualizer as they are suitable for rendering photographs and illustrations when colour specification need not be accurate.

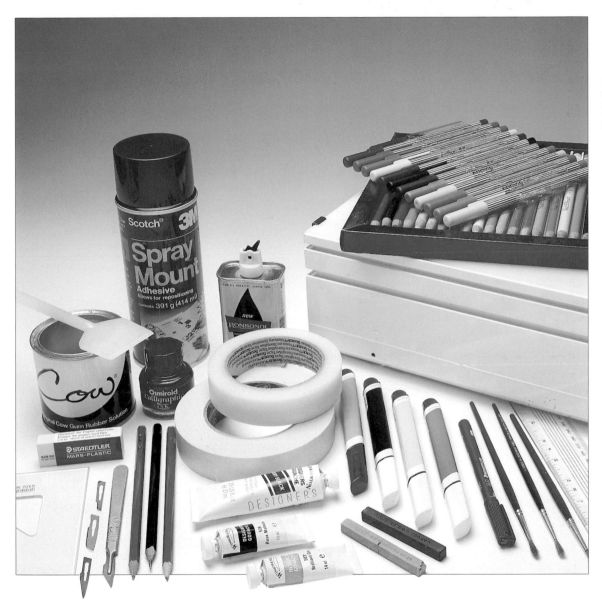

A number of tools are essential for creating visuals. Although you will have your own preferences, the selection here should cover most requirements.

1. Spray glue for mounting visuals.
2. Cow gum and a spatula to apply it; cow gum is useful for mounting non-spirit-based marker work.
3. An eraser.
4. A plastic set square.
5. A scalpel holder and a selection of blades; 10A blades are the most commonly used size.
6. A selection of pencils, preferably the softer B range.
7. Black ink.
8. Lighter fuel for dissolving excess glue.
9. Magic tape; this is sometimes known as invisible tape.
10. Masking tape; this has many uses, and you should buy the low-tack tape, which does not damage work.
11. White and black gouache.
12. Coloured gouache.
13. A range of fine line markers.
14. A selection of coloured pencils.
15. A light box for viewing transparencies and to enable you to trace over elements of your design.
16. A range of PANTONE markers, which are available in different nib widths and whose colours relate directly to printers' inks.
17. Coloured hard-chalk pastels.
18. A fine liner pen for drawing.
19. Sable brushes for indicating lettering and for painting fine details.
20. A clear plastic ruler.

Both these brands are popular because they are consistent in quality and have the capability to produce perfectly flat colour blocks as well as flexible gradations.

There are several other items that are not so critical in the initial stages, but you should consider purchasing a light box, a range of hard and soft pastels, a good range of gouache colours, inks and pens, fixatives, a small can of lighter fuel and an airbrush for creating special effects.

Materials: surfaces

CHECKLIST

- Use a good size layout pad – A2 is recommended – and try out the different qualities of paper available.

- Mount visuals on cartridge paper.

- Obtain tracing paper for detailed rendering and for producing your own carbon.

- Have a range of coloured papers to assist in visualizing.

- Investigate the mounting surfaces available for display.

Over the years a great many papers have been developed for the purpose of creating visuals. Different visualizers have different preferences, and it would be beneficial for you to try out a number of surfaces. The papers are available in pads, and I recommend that you buy A2 pads, which will give you ample space for any job.

The paper you work on should be suitable for the application of markers, and I prefer a paper that is translucent enough to allow me to trace an image placed underneath it without having to use a light box. The main problem with these papers is their non-bleed-proof quality. This means that when the marker is applied to the pad of paper, the colours can seep through to the sheets below. There is little you can do about this as you need that absorbent quality to achieve the best from the markers, but the waste incurred in their use is obviously a major disadvantage.

A bleed-proof paper has been developed and is now used extensively by professional studios. This paper has the advantage of having a whiter surface, but it lacks the translucent qualities I mentioned.

You will also require cartridge papers of various thicknesses on which to mount the visuals, and you will need a selection of coloured papers to use both as an ingredient of the visual and as dust covers to protect your work. Sheets of clear adhesive plastic can be cut and used to give your visual a glossy look.

You will occasionally need tracing paper for rendering type. Tracing paper has another use as a substitute for carbon paper. There are acetates that take the marker pens, but this surface is normally used only in the preparation of finished visuals.

Finally, there will also be occasions when you need to display your rough visuals. You will find a full range of boards or card displayed at your graphic design supplier, and you should mount your visuals onto board to provide a firm surface that will both protect and enhance them.

■ You will need a range of drawing surfaces and materials to create visuals.

1. A pad of bleed-proof paper.
2. A pad of non-bleed-proof layout paper.
3. Tracing paper.
4. Cartridge paper for mounting your visuals.
5. A range of PANTONE papers, which are produced in colours that match printers' inks and the range of PANTONE markers.
6. Mounting board for displaying your visuals.
7. A range of coloured papers, which you will use both in the process of creating visuals and as overlays to display your work.

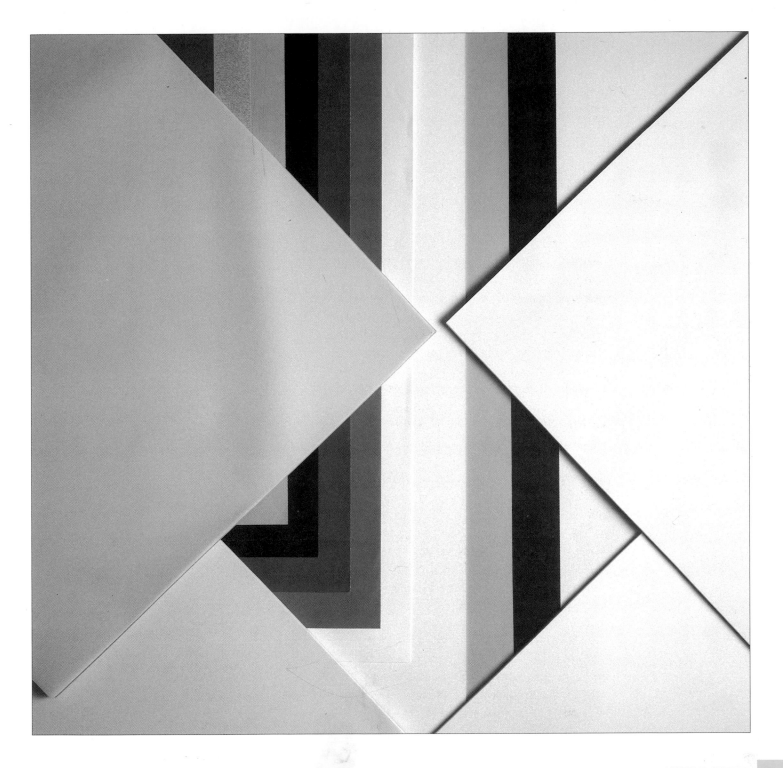

How to use the materials

CHECKLIST

- Set out the surface you are going to work on.
- Tape down a sheet of non-bleed-proof layout paper.
- Fold a couple of sheets to use for blotting.
- Bleed-proof papers can be worked on from the pad.
- Work out the shape and size of your design so that you can fit more than one onto the page.
- Try out the markers and drawing instruments on the edge of the working surface.
- Sharpen all the pencils using a craft knife.
- Set up a small table alongside your working area.
- Seat yourself comfortably and ensure that the lighting is good.

The first task is to set out the surface you are going to work on. If you select a non-bleed-proof layout paper, you will need to remove a few sheets from the pad and place them on your drawing board or work surface. I suggest that you tape down one sheet to the board and carefully fold the other sheet or sheets into halves or quarters, placing them underneath the working surface to absorb the bleed from the markers. If you are using bleed-proof paper, there is no need to remove a sheet from the pad.

You next need to work out the shape and size you are going to be working to, bearing in mind that each sheet of layout paper will be used to produce a number of visuals from the same concept.

Next, try out all of the drawing instruments on the edge of your layout paper to ascertain the range of colours and marks that can be made. I always use the edge of the sheet to test a colour or mark because this not only helps me to decide if I want to use a particular colour in the design but also provides a continuous colour swatch for visual reference. Remember: always do this on the edge of the paper as this will be cut away at a later stage.

It is always advisable to have a separate small table or a surface away from your working area as you will need to stand a water pot for the gouache paint, as well as all the instruments I have described. Your pencils will need to be sharpened, and the best point can be produced with a craft knife.

Finally, ensure that you are comfortably seated over your working surface with, if possible, a light projected onto the surface from both sides. This is easiest if you have two angle-poise lamps.

1

2

3

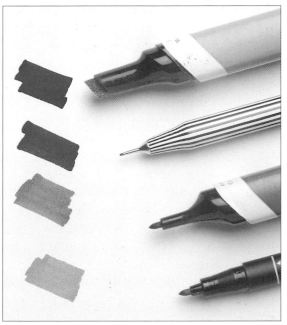

4. Make sure that your pencils are kept sharp. You can alter the shape or point of a fibre-tip marker by cutting it carefully with a scalpel or craft knife.

5. Test your markers on the edge of your layout pad before applying them to your visual so that you can note the sort of marks they make.

6. Remember to experiment with your pen; it is possible to produce a variety of marks with most pens simply by altering the holding position.

5

4

1. Tape down the layout paper to your drawing board. Placing a pad of layout paper underneath will not only absorb any bleed but will also give a better quality surface to work on. You can use this approach for tracing off and for developing drawings.

2. Set up your drawing board so that your working position is comfortable and the lighting does not throw shadows on your work.

3. Test your colours on a separate strip of paper before applying them to the visual. Although this is not always necessary, it is essential if you are using flesh tones or trying to obtain a special match.

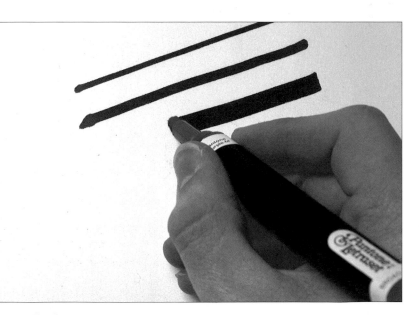

6

When you have produced some roughs you will need to display them in some form or other – flat or made up as packages and so on. The rough will have to be carefully cut from the surface of the layout paper with a very sharp craft knife and positioned on a clean surface. Cartridge paper would normally be the first surface onto which the rough would be fixed. Most studios use a spray glue to fix these two surfaces together. This glue, which can be purchased at a graphics supplier, is sprayed as a fine mist, so carefully hold the rough in position and spray the glue onto the reverse side. To contain the spray and to protect other surfaces, I recommend that you cut the front from a large cardboard box, retaining the other five sides, and make a platform with mesh wire inside the box (or see 2 below). The rough can be placed inside the box with the surface to be sprayed facing out. This spray booth will soon become a permanent feature of your studio.

Before spraying, the surface for mounting will need to be laid out. If the surface is only a flat support for the rough, it may not be necessary to mark it up for accurate positioning. If, however, it is for a package or a specific shape, the accurate outline will need to be lightly indicated on the surface before you fix the rough. You may then wish to mount this again, cut to shape, onto a display or mounting board. Alternatively, you may need to fold the surface into a shape or package. A usual method of scoring is delicately to cut, using a sharp craft knife and ruler, the surface of the layout paper, and you will then be able to fold the cartridge underneath as this has not been cut.

Coloured papers can be cut into shapes to be used in the process of making rough visuals. As we have seen, tracing paper will mainly serve two purposes. The first of these is its normal use for tracing off visual details. Its next use is as a form of carbon paper. To prepare it for this, take a soft pencil – a 4B or 6B – and cover one side of the paper in a heavy layer of dense grey. If you tuck this between two surfaces of your layout paper you will find that you can transfer the image from one surface to another by drawing with a sharp instrument.

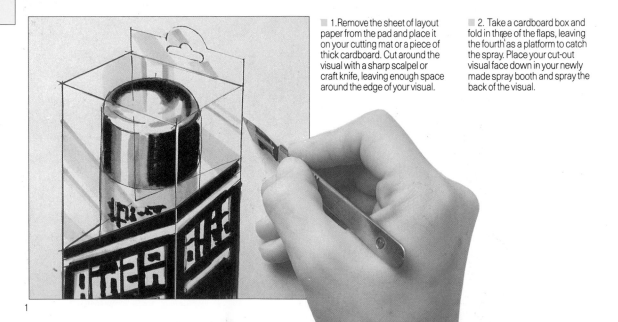

1. Remove the sheet of layout paper from the pad and place it on your cutting mat or a piece of thick cardboard. Cut around the visual with a sharp scalpel or craft knife, leaving enough space around the edge of your visual.

2. Take a cardboard box and fold in three of the flaps, leaving the fourth as a platform to catch the spray. Place your cut-out visual face down in your newly made spray booth and spray the back of the visual.

1

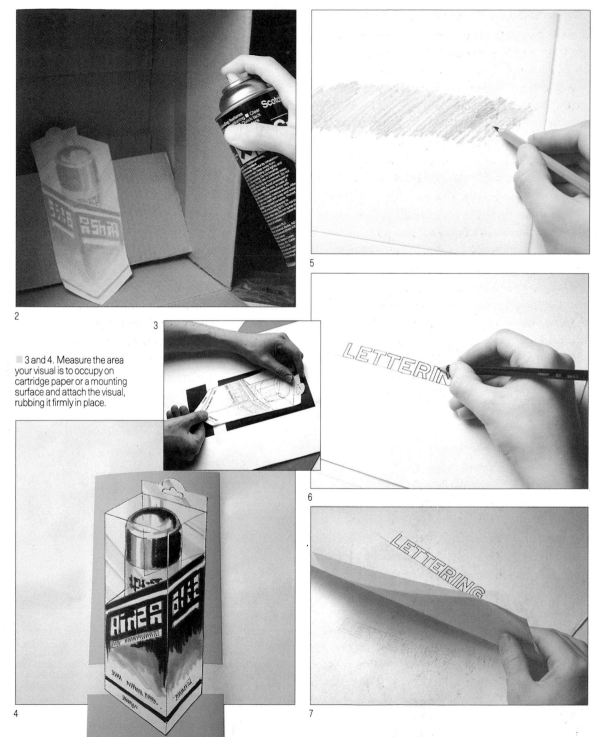

5. You can buy trace-down or carbon paper, but it is easy to make some by rubbing soft graphite pencil, red Conté or, for reversed images, white chalk onto the back of a piece of layout or tracing paper. Place this under your drawn-up lettering, facing the surface to which you want to transfer the lettering.

6 and 7. Once the carbon is in position, place your drawn image over it and the surface onto which it will be traced, firmly attaching all three sheets together with masking tape. Trace over the image using a sharp, hard pencil. Lift off the top sheet and carbon, to reveal the image transferred to the bottom sheet.

3 and 4. Measure the area your visual is to occupy on cartridge paper or a mounting surface and attach the visual, rubbing it firmly in place.

2

3

4

5

6

7

Other visualization media

Not all designers favour markers as a principal medium for visualization. The choice of medium is a personal decision and the best method of working for each designer can only be discovered by extensive experimentation. It is therefore important in the early stages to investigate and experiment with a number of media. You will also discover that media can be mixed to achieve specific effects and even the projects themselves will sometimes dictate the use of particular instruments.

The only way you will arrive at the right creative visual is by trying out a number of alternative media. In the professional world there are no absolute controls over the way you work. In fact, as long as your rough communicates with visual precision and you are able to produce this swiftly and economically, then your client will be happy with the presentations.

Possible media include a range of wet painting methods, from designers' gouache, an opaque, flat medium, to watercolour, a translucent wet painting method. There is a massive range of designers' coloured pencils with a choice of colours that would cover any job situation. These pencils are also available in water-soluble colours and there are many reputable graphics suppliers producing them.

Inks are another option and again these come in different qualities and colours with either a water or a shellac base. It is advisable to use the water-based ink with airbrush equipment, as the shellac inks will ruin the mechanism.

Pastels are a delightful medium for illustration visuals. They can be used on their own or in conjunction with other media, such as markers, where they can be overlaid to highlight or soften the marker colours. Coloured pencils can also be used in this way.

These are some of the traditional approaches to the creation of rough visuals, but as we move further into the technological age, there are new and swifter approaches. The Omnicrom process has become an established tool of the design studio and it simplifies the reproduction of visual alternatives. The advantage of Omnicrom is its potential for changing your black and white visuals into a host of colour

Soft and hard pastels are useful as the basis of a colour visual when attention to detail is of secondary importance. Pastel may be easily fixed with a proprietary fixative. Gouache may then be overlaid on the drawing to create highlights, although you may find it necessary to mix the paint with a little household washing-up liquid.

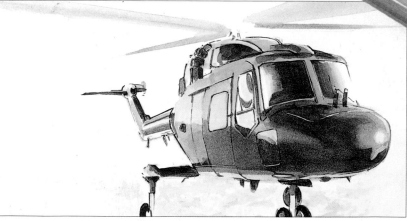

■ Many designers use coloured pencils to create visuals, for not only is there a huge range of colours but they are also flexible enough for almost any visualizing job. The pencils available range from ordinary coloured ones to the water-soluble type, which can be useful for illustration.

■ The illustration of the helicopter was produced with traditional watercolour paints. I find that this medium has a similar effect to that produced by markers, but watercolour gives the designer much greater control.

alternatives. However, the most revolutionary development is computer graphics equipment. With today's technology you are able to control and create original visuals to a high standard of finish, giving your client a range of exciting interpretations of the design brief.

You can see the wealth of working media that is at the designers' disposal. Study the examples on these two pages – and in the rest of this book – to uncover the choices made by different designers.

Overlays of tone and colour

CHECKLIST

- Produce a flat wash in a single colour.
- Make a gradation by overlaying the wash several times, stopping short each time.
- Blend the gradation with solvent and cotton wool.
- Create a chequered pattern.
- Different colours overlaid on the surface will create convincing images.
- Cut out and spray mount various elements.
- Enhance detail by using fine markers.

To get full value from the effects that can be achieved some further experimentation will help. Often, if you are trying to reproduce photographic images or backgrounds for designs, you will need to apply gradated colours. The advantage of using professional markers is that you can overlay a single colour, or a mixture of colours, many times in the pursuit of a darker tone or special colour.

Take a single colour and lay a flat wash within a small shape. Working from the top of this shape, gradually overlay the wash with the same colour. If you stop short of the bottom of the wash and repeat the overlay a number of times, stopping short of the previous overlay each time, you will produce a gradated colour. Try crossing your marker in a chequered pattern to show the different densities of colour that can be achieved.

To blend gradated colours and overlays of different colours, wipe the edge of the overlay with cotton wool soaked in a solvent. This will blend the colours and remove any hard edge.

Another great advantage of this medium is the freedom it gives you to mix colours together on the paper to produce further colours, which is particularly useful in effecting roughs for illustrations. If you are drawing people, cars, equipment or products, you can achieve great likenesses with very limited material and simple overlays of colour.

Once you have drawn up the elements of a design, these can be cut out and spray mounted together to create a whole effect. An example could be a design brief that demands a gradated background with a detailed object or subject in the foreground. The easiest way to produce this is to separate the elements into two exercises, to cut them out and to spray mount them together. This method of collaging is extremely useful in the making of decisions when creating rough visuals.

Lastly, finer markers can be drawn over the colours to pick out details.

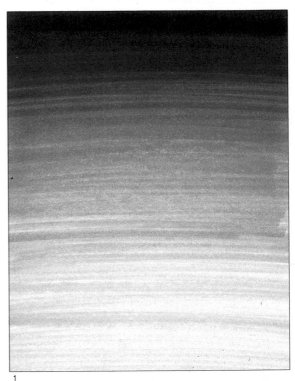

1

■ 1. This gradated colour was produced by the gradual overlay of a light blue marker by a darker colour. A gradation is easily created by applying the heavier layers only in the areas you want to be dark.

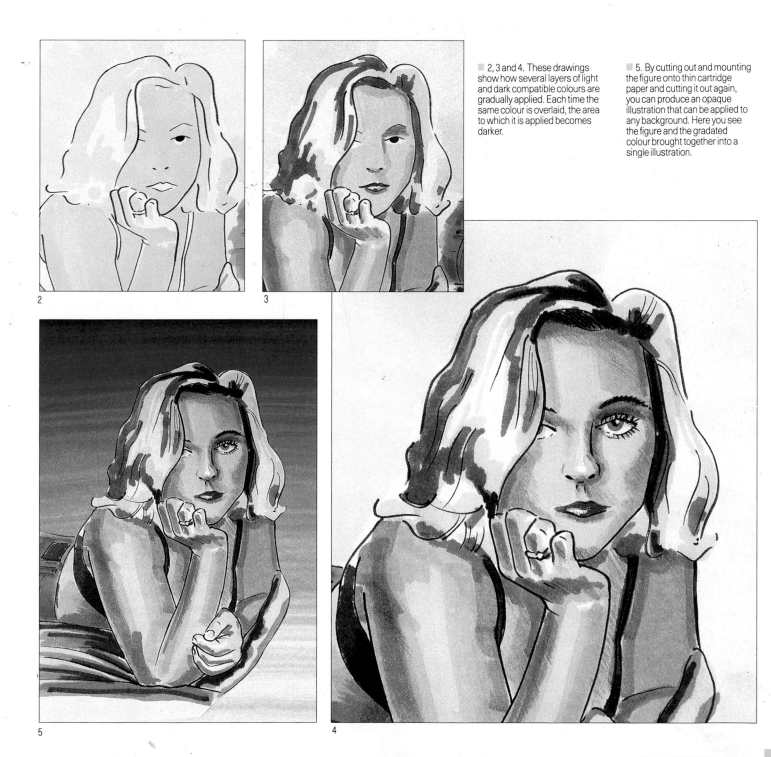

2, 3 and 4. These drawings show how several layers of light and dark compatible colours are gradually applied. Each time the same colour is overlaid, the area to which it is applied becomes darker.

5. By cutting out and mounting the figure onto thin cartridge paper and cutting it out again, you can produce an opaque illustration that can be applied to any background. Here you see the figure and the gradated colour brought together into a single illustration.

2

3

5

4

Drawing up the shapes for your rough visuals

CHECKLIST

■ Understand the concept.

■ Establish the size and format.

■ Experiment within the size and format.

■ Think of it as a physical presence.

■ Keep the correct scale throughout the process.

■ Compare the ideas to see how they suit the concept.

■ Produce shapes simply with a black or grey medium marker or cut a mock-up out of paper.

In every design concept certain specifications govern the size and possibly the shape of the design area. The concept that is arrived at is the basis from which the visual emerges. Assuming that this stage has already been established, it is now time for the visual interpretation. For example, assume that you have to produce a rough visual for an A5 leaflet. All the text has been written, the illustrations or photographs have been produced, and some idea of the styling (type styles, and so on) has been agreed. Clearly, there is still a great deal left for interpretation. For instance, how do you use the size and shape allocated? Do you fold it in half or into thirds? Do you cut out pieces? Do you eliminate some of the area by printing a shape within it? If there are a number of pages, how will they be stitched together? In short, you should think of the shape for your visual as an object to be played around with. Think of its physical presence. You can even make a little mock-up of the pages. However, the most important thing to remember in this process is to retain the correct scale throughout the creative development. No matter how many versions you produce, they must always be in proportion to the finished piece. They must also be in proportion to one another to enable you and your client to recognize the scale you are working at.

You can use a choice of instruments in drawing up the shapes, although a single, medium thickness black or grey marker is really all that is required once you have made an initial, accurate pencil outline.

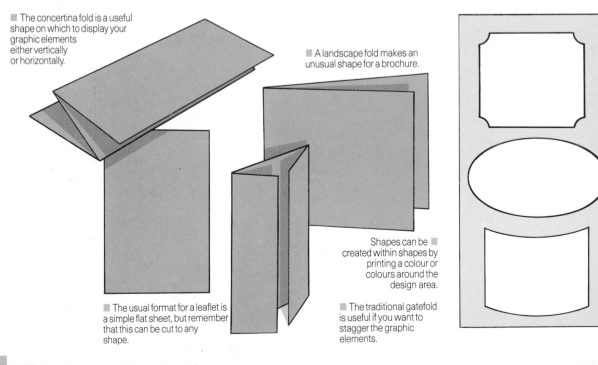

■ The concertina fold is a useful shape on which to display your graphic elements either vertically or horizontally.

■ A landscape fold makes an unusual shape for a brochure.

Shapes can be ■ created within shapes by printing a colour or colours around the design area.

■ The usual format for a leaflet is a simple flat sheet, but remember that this can be cut to any shape.

■ The traditional gatefold is useful if you want to stagger the graphic elements.

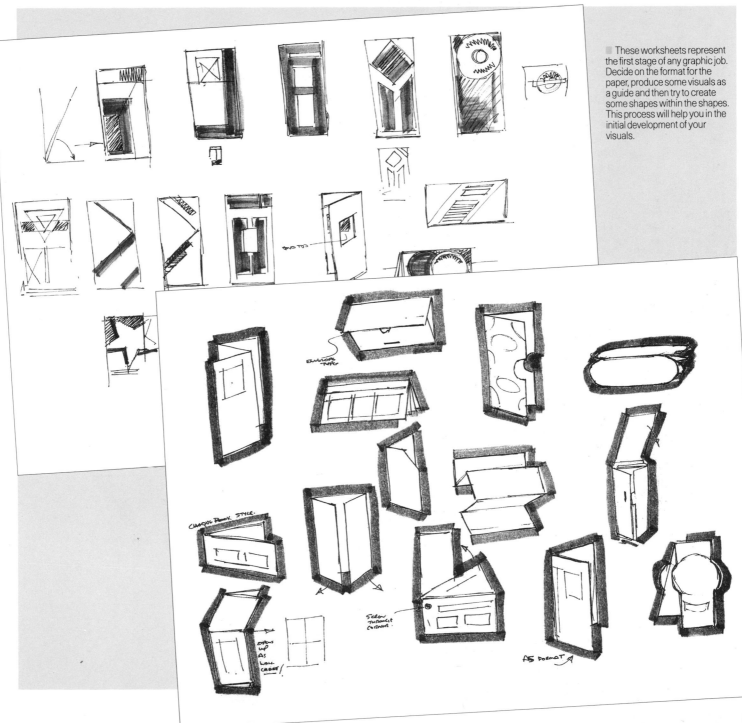

These worksheets represent the first stage of any graphic job. Decide on the format for the paper, produce some visuals as a guide and then try to create some shapes within the shapes. This process will help you in the initial development of your visuals.

Making initial thumbnail sketches using markers

CHECKLIST

■ Draw up a series of the pre-designed shapes.

■ Place the design elements within the shapes to make alternative layouts.

■ These elements need only be squiggles and blocks – no detail yet.

■ The sketches are called thumbnail sketches.

■ The sheets are called scamp sheets.

■ No detail is required at this stage, just a feel for the elements.

■ Be conscious of time.

■ Work imaginatively, swiftly and accurately.

Once you have established some interesting shapes for the design you will now need to give some thought to how the elements of the design will be incorporated within the shape.

The procedure for this is quite logical and requires a systematic method of working. You will produce a number of alternative arrangements on a single sheet of layout paper. These will be done at speed, the elements within the chosen shape being identified quickly. The sketches are known as thumbnail sketches, and the sheets on which they are produced are known as scamp sheets. You must still make sure that all of the sketches and the elements of the design are to scale and in the correct proportions. Remember, at this stage of the design all you are trying to establish is a feeling for the elements within the selected shape.

You need not worry about accurately conveying elements such as typeface or detailed pictures; instead, you should concentrate on establishing as many visual alternatives as time will allow. Be conscious of time in all your visualizing pursuits as each job will normally be costed on an hourly basis. This discipline does three things. It makes you organize your methods of working; it pushes you to think fast; and it makes you cost and quality conscious. As I have stated before, visualizing is a well-paid sector of the design industry, so conscientiousness is paramount.

■ This close-up of one of the thumbnail sketches, which is reproduced larger than actual size, will enable you to see the amount of detail required at this initial stage.

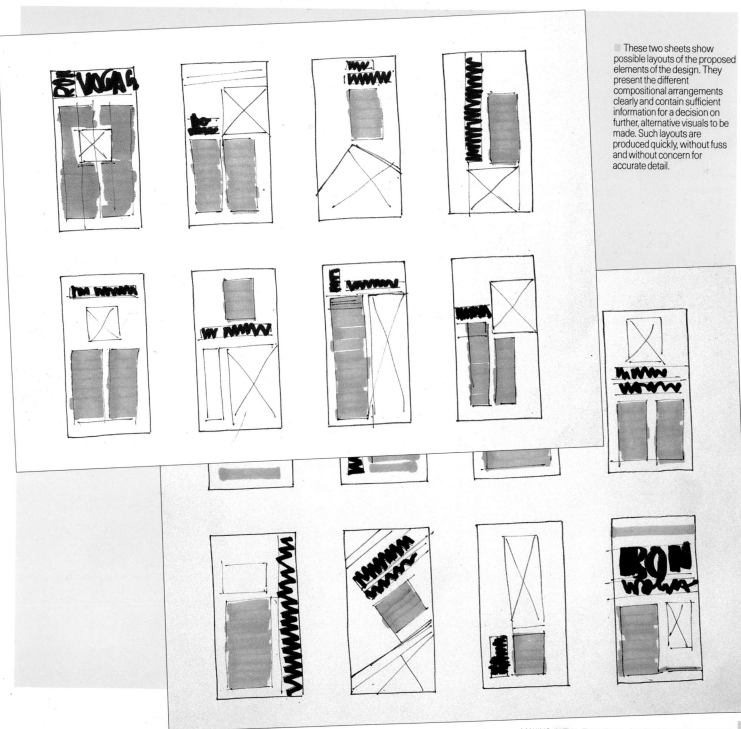

These two sheets show possible layouts of the proposed elements of the design. They present the different compositional arrangements clearly and contain sufficient information for a decision on further, alternative visuals to be made. Such layouts are produced quickly, without fuss and without concern for accurate detail.

Introducing colour scamps in markers

CHECKLIST

- ■ Set up your work area with the colours you will use.
- ■ Be selective with your colours.
- ■ Find tints of those colours.
- ■ Make sure you have both thick - and thin-nibbed markers.
- ■ Draw up a series of the pre-designed shapes.
- ■ Try some alternative layouts in different colours.
- ■ See how these colours affect the design.
- ■ Use a mix of colours on a single design.
- ■ Create a variety of different textures and surfaces.

Colour introduces another dimension to your work. Any colour – from the use of just a single colour, with its scope for tints and various shades, to the mixing of two colours, through to the full range – will give you more possibilities in the appearance of your work and will broaden the range of devices you can incorporate into your roughs.

Colour must be carefully handled. You need to give some thought to the colours that will complement the design in hand. If it has been indicated in the initial concept stages, you will have to interpret the choice of hue you will use. For instance, if it has been decided that blue and beige are to be explored, you will need to consider what type of blue or what type of beige is most suitable. This is why it is so important for you to plan your set-up before you begin to work. An important point to remember and to exploit is that colours can radically change a design.

The logical process in the development of ideas runs from the initial concept to the shape and placing of the design elements, to the introduction of colour. It is at this stage that you can begin to evolve some genuine choices for comparison.

As you should already have created some initial scamps, now is the time to take two or three of these and experiment with the use of colour, exploring different possibilities. Start by keeping the colours simple. Take a single colour and try some tint devices based on this colour. Introduce another colour into the same thumbnail. Try some different versions using the same colours in alternative arrangements. There is no end of possibilities. Do not be afraid of producing too many scamps. Exhaust all your ideas.

Finally, designs can often be made more exciting by the introduction of more textural effects, which can be created by stippling colours together, blending and overlaying them as I have shown.

■-Choose your marker pens carefully, bearing in mind not only the proportions of the graphic elements to be included in your visual but also the variety of marks that can be made by each individual pen.

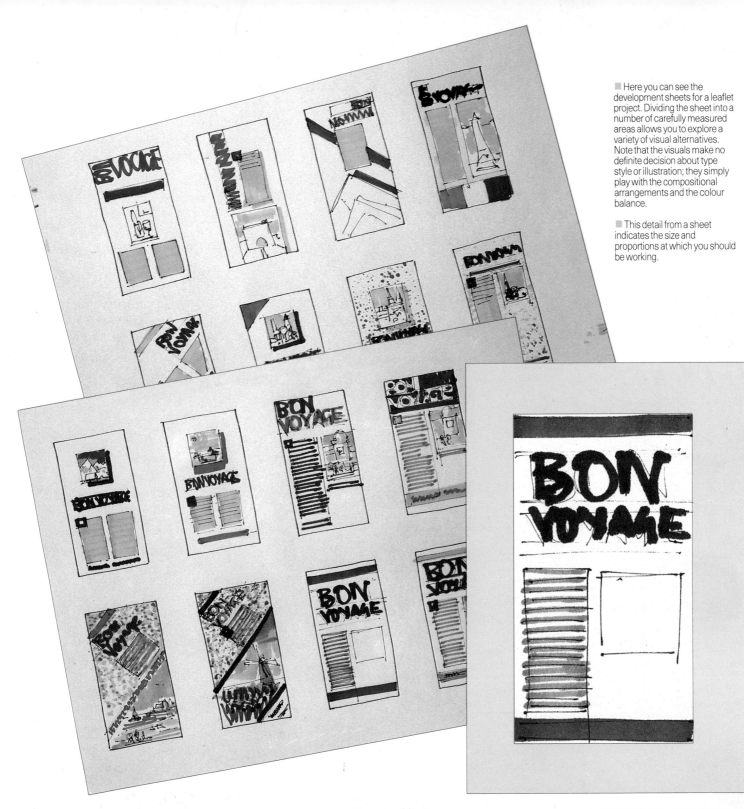

■ Here you can see the development sheets for a leaflet project. Dividing the sheet into a number of carefully measured areas allows you to explore a variety of visual alternatives. Note that the visuals make no definite decision about type style or illustration; they simply play with the compositional arrangements and the colour balance.

■ This detail from a sheet indicates the size and proportions at which you should be working.

Indicating lettering in your scamps

CHECKLIST

■ Choose a few appropriate typefaces.

■ Make sure that you are fully aware of the characteristics of these faces.

■ Draw up the parallel lines in pencil.

■ Draw up the letter forms quickly but accurately in position.

■ Check the spacing between the letters.

■ Check the spacing around the letter forms.

■ Overdraw the letters in pen to indicate the style.

At some point you will need to start having some idea of the typeface or faces that are going to be used in the rough. Up to now these have been indicated by loose squiggles, but now it is necessary to indicate some notional presence of type.

To do this you will need to refer to the typefaces that are going to be appropriate to the design. Again, this must be done with speed and accuracy, but without going into detail. All you should be aiming for is to give the merest indication of the letter forms.

The technique of indicating lettering needs a fair amount of skill. The first of these skills is an understanding of letter spacing and type pro-portions. The next is an ability to draw these quickly but precisely in a chosen position. Most visualizers draw up parallel lines to the height of the capitals or of the lower-case letters in light pencil and use the lines to carry the letter forms. Again, pencil will be used to indicate the letter forms in position. It also takes a little time to be able to space the letters in correct proportion to the design area into which they are to fit. This skill takes a deal of practice to master.

Having established the method you are going to use, you can experiment with alternative typefaces in various sizes and with a variety of spacing ideas. These will enable you to arrive at more definite conclusions about the style and effects you are trying to achieve. Normally, this indication of lettering would be produced quickly in pencil and finished by overdrawing the pencil lettering with a marker that has a nib to suit the typestyle.

Once you have arrived at some interesting arrangements, introduce colour into the layout to increase the visual effectiveness of your rough.

■ Study a typesheet or sheets for possible letter styles. Carefully analyse the shape of each letter, and you will soon learn to recognize and memorize their appearance.

■ Use pencil to draw two parallel lines representing the height of the upper case lettering. Study the shapes made by the letters so that you can draw each of the forms.

BON VOYAGE
BON VOYAGE
BON VOYAGE

Use different instruments to produce several alternatives to see which are the most suitable for achieving the effects you want.

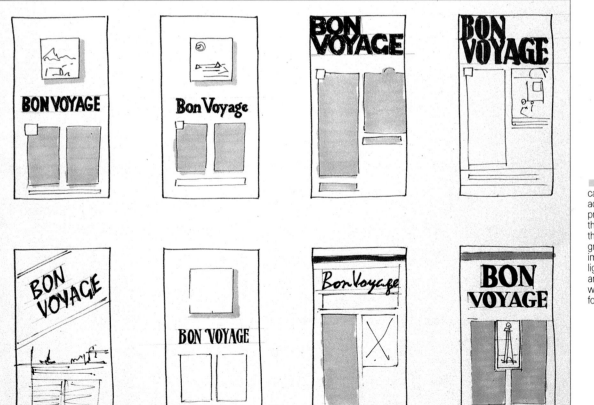

Once you are confident that you can produce letter forms neatly and accurately, render them in different proportions and type styles within the design area. You will notice that the balance between black and grey in these visuals gives an impression of bold headings and lighter body text. Different arrangements of these elements would produce alternative visuals for consideration.

Indicating type in your scamps

When it comes to indicating blocks of type in your visuals it would be impracticable to try to illustrate every letter or word. Therefore you need to be able to draw copy in an abbreviated form that still conveys the essence and feeling of the type eventually used in the printed piece. Over the years many systems have been developed effectively to describe the feeling of copy. Most pieces of design will rely on the visual display of text in different weights and point sizes, and its subtleties and nuances are paramount both to the rough stage and to the appearance of its finished form. Therefore, each design job needs to be considered on its own merits, and the method and extent of the indication of type and text demand detailed thought from the visualizer.

What are the options? The first is to use pre-set body type, which is printed on clear plastic sheets that you can cut to shape. The disadvantage of this pre-set type is that it may well not complement the free style used in creating your visual. It is mainly used for highly finished visuals and should be avoided in the production of rough visuals.

The next options are the recommended ways of describing type. The first of these is simply to draw parallel lines that reflect accurately a line of type. These are drawn horizontally to indicate the lower-case letter forms. Naturally, the number of lines will be governed by your estimation of the length of the text; this needs to be only a rough guess, although some accuracy is required as the positioning of the lines has a direct bearing on the spacing of the actual type and its point size. Moreover, the weight of the horizontal lines should reflect the weight of type being used. If the type is to be heavy, a heavy line is

required; if the typeface is quite light, then, clearly, a light line is appropriate. You should be able to see from this that some control of how dense or light the type will be is established at a very early stage.

The next system in use is calling "N-ing". You can see from the illustrations why this name is used. Other methods are illustrated that are similar to this way of working. "N-ing" is a more skilled process of indicating type, but it can be used and controlled to greater effect as it really attempts to define and give identity to the actual printed type forms.

The tools recommended for these processes are highly developed fibre pens.

You can now combine a heading with an indication of the body type, thereby establishing some of the principal skills in making initial roughs.

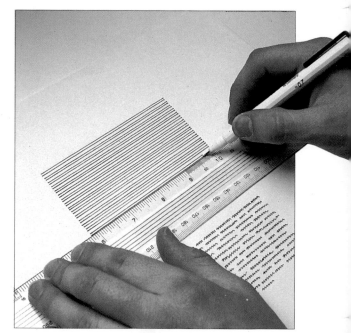

■ The four examples of rendered body text on this page show the methods that can be applied to visuals. The first example is called body copy; it resembles actual type and is available from graphic materials suppliers in rub-down form. The other methods shown are grey lines produced with a marker pen, parallel lines drawn with a fine liner, and the squiggle effect known as "N-ing".

■ You can see from the visual of Paris that a combination of ruled lines, boxed rules and tint is sufficient to indicate the appearance of the text within the design.

Lorem ipsum dolor sit amet, consectetur adipscing elit, sed eiusmod tempor incidunt ut labore et dolore magna aliquam e enim ad minim veniam, quis nostrud exercitation ullamcorp oris nisi ut aliquip ex ea commodo consequat. Duis autem dolor in reprehendert in voluptate velit esse molestaie consequ dolore eu fugiat nulla pariatur. At vero eos et accusam et justo praesent luptatum delenit aigue duos dolor et molestias exceptum dupic non provident, simil tempor sunt in culpa qui deserunt mollit anim id est laborum et dolor fuga. Et harumd dereund facilis est er expedit distinct. Nam liber tempor cum nobis eligend optio comgue nihil impedit doming id quod maxim placeat facer possim omnis voluptas assumenda est, omnis dolor repellend. Temporibud autem quinusd at aur office debit aut tum rerum necessit atib saepe eveniet ut er repudiand sint et molestia non recus. Itaque earud reruam hist entaury sapiente delecatus auaut prefear enrdis doloribr asperiore repellat. Hanc ego cum tene sententiam, quid est cur verear ne ad eam non possing accommodare nost ros quos tu paulo ante cum memorie tum etia ergat. Nos amice et nebevol, olestias access potest fier ad augendas cum conscient to factor tum poen legum odioque cividua.

Rendering lettering: on roughs

CHECKLIST

- Draw up the heading to a number of sizes and in a number of type styles.

- Offer this up to the design space.

- Position the heading and trace it down using tracing/ carbon paper or by applying white pastel to the reverse side.

- Remove the trace to leave a pencil indication of the type on white or a white indication on black.

- Use a white pencil to draw the lettering directly on to the black.

- Black in the type with a fine liner or white it out using a brush and thick white gouache.

- Ensure that the body copy indicated accurately reflects the actual text.

Once you have developed the skills of rendering headings accurately on to your tracing paper, you are ready to offer them up to the design area. Using one size of type and style would limit the possibilities of creating visual differences, so prepare a number of well-chosen faces for the same heading. The advantage of using tracing paper for the type is that the words can be seen clearly when they are placed over the actual design area.

The scamps that have been produced quickly have brought you to the point when proper roughs can be produced. The roughs will be prepared on a larger scale and with more care than the scamps, as the detail required is much greater. They may even be produced to the finished, printed size.

The next step is accurately to position the lettering over the design space so that it can be traced down onto the rough. The lettering may eventually appear in black on white or it may be reversed out of black or printed in colour. To trace down for black lettering you simply use the prepared tracing/ carbon paper. If the letter forms are to be reversed out, white pastel or chalk applied over the back of the lettering on the tracing paper will enable you to draw the image so it is produced as a white outline on the dark surface, although a professional would draw his lettering directly onto the background using a white pencil.

Once traced down, black lettering can be drawn in using a marker; the white lettering, which appears as a chalk or white outline, can be painted in using white gouache paint and a sable brush. Make sure that the white gouache is not too watery a mix as it will cockle the light layout paper. If you mix the gouache to the thickest consistency you will avoid this problem.

The body copy would still be indicated either as lines or simulated type through "N-ing". It is important, however, that the copy that is to be applied to the design is accurate in both form and the space it occupies, so care will be needed to ensure that you have indicated the correct type size for the amount of text. A simple character count will quickly show you how many letters fit in a line.

Draw a number of versions of the word in different styles of type. These will be used in the selection of visual alternatives.

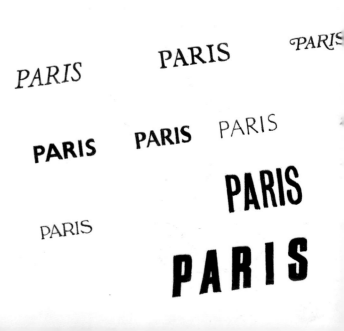

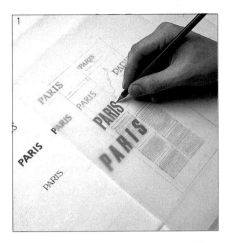

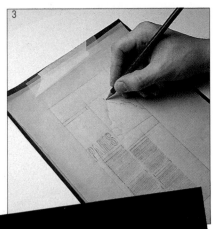

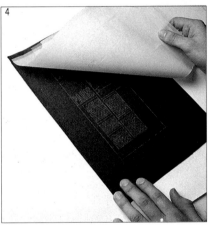

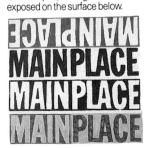

■ This repeated piece of lettering uses the reversing-out technique as a design feature. The work seen here was produced by inking around the letter shapes, leaving the word exposed on the surface below.

■ To reverse out an image:
1. Trace the lettering and all the graphic images onto tracing paper.
2. Apply white pastel or Conté to the reverse side of a separate sheet.
3. Place this sheet between the tracing of the graphic elements and a piece of black paper, with the white chalk side facing the black paper, and follow your original outlines to re-draw the graphics.

4. When the drawing is complete, remove the carbon sheet and lift up your trace before detaching it to see how well the white chalk has been transferred to the black surface.
5. Mix some white or coloured gouache and paint in the graphic elements using a sable brush. Fine lines can be drawn with gouache in a ruling pen.

■ This visual is the result of the stages seen above. It can be developed further by attaching illustrations or by applying more detail in gouache.

Imaginative lettering

CHECKLIST

- Change and distort existing forms for your own design.
- Use different instruments to create different effects.
- Study the possibilities of inventiveness in body copy.
- Use your freedom to the full.
- Apply some simple techniques to introduce changes.
- Include patterns or textured surfaces in your roughs.
- Personalize the design.

One of the great freedoms of visualization is the scope it offers for developing and producing original pieces of work. The visualizer can experiment, change, distort and create new images out of old. It is easy with a quick flick of a pen to change a solid letter form into a multicolour, outline letter form. Type can be bent or squashed; shadows can be put above or below it; and all manner of exciting ideas can be explored. Similar innovations can be applied to body copy – colours can be dropped in, type can be shaped around objects, large letters can be dropped in to emphasize paragraphs or just to create interesting patterns. The excitement of visualizing comes from the freedom to invent. However, be warned: your client has a limited budget for the work, and hand-produced works can be costly and sometimes difficult to reproduce.

There are some simple techniques that enable you to create different images from a standard letter form. For instance, if you take a solid letter and draw it up as a black outline, you will have changed its solid form into an interesting linear shape. If you then move the letter as it appears on the tracing paper and lay it over the black outline, but off centre, you can create anything from a double image to a dropped shadow. This can be filled in as a tint or colour or even as a patterned or textured surface.

Another approach is to take a letter form and change its characteristics. Round off the edges, fatten up the body, add bits or remove them and generally personalize this for the design.

■ When you have produced a number of type styles in black, you can place another sheet of tracing or layout paper over them and develop some interesting and colourful variations. You will find that there are many, many ways to use the type. For example, you can draw the solid letter forms as an outline, or you can fill them in with a colour and have an outline running around them.

■ Produce a worksheet to show the different styles that are possible so that you can easily refer to them when you are creating your visuals.

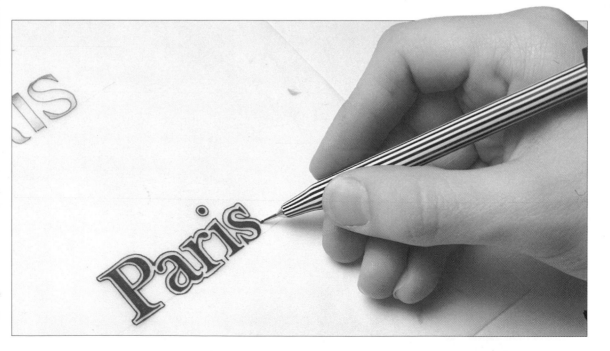

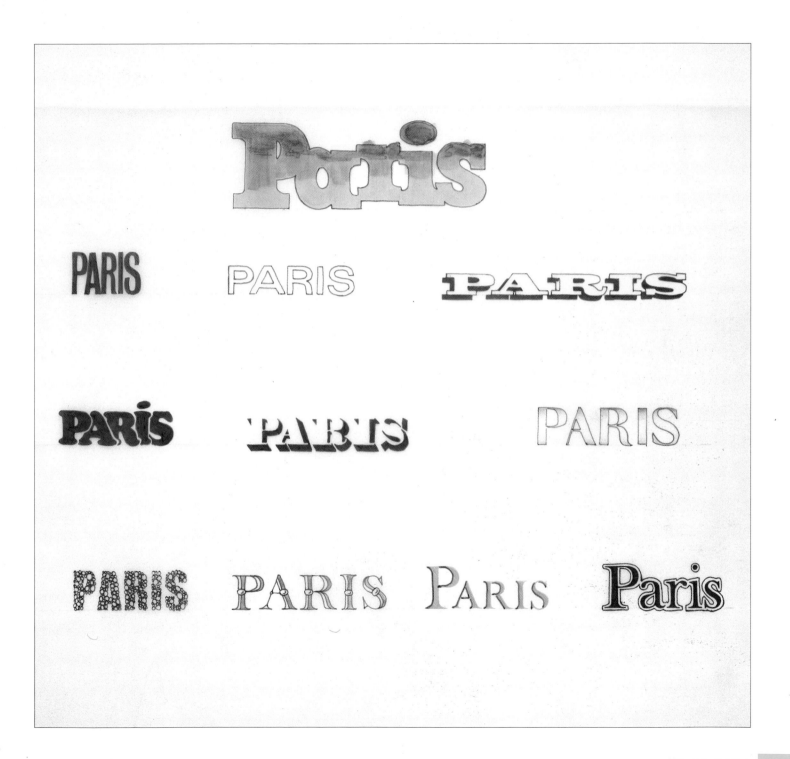

Rendering lettering and type with colour

CHECKLIST

■ Produce thumbnails first.

■ Discard the designs that do not work.

■ Use colour.cautiously and to good effect.

■ Remember that tints can often be more effective than excessive use of colour.

■ Emphasize elements of your design with well-chosen colour.

■ Test the compatibility of colours, using the edge of the layout pad.

■ Have a full range of colours for these experiments.

■ Remember: legibility is paramount.

The degree of experimentation that can be achieved with a few design elements is almost infinite. You can give the same elements to a number of designers/visualizers, and you will have as many interpretations as there are designers. The way a piece of work is interpreted will always be personal to you.

Before attempting elaborate roughs you should go back to producing thumbnail sketches so that you can quickly eliminate any over-colourful designs and those that fall flat. Any number of colour combinations can be explored, including some loose and unconventional effects, but often a tint of the colour will create a better effect than using an additional colour.

Use colour in a design to help you to communicate the visual message, but beware of the over-use of colour, as this can detract from the desired effect. A more controlled and subtle approach will be more likely to give you the quality that you seek.

Colour can be used to emphasize and draw attention to an area of the design; it can also be used to subdue elements. Remember, legibility is important to the success of the visual, so when you choose the colours with which you wish to work, ensure that they are compatible with the elements of the design and allow the text to be read.

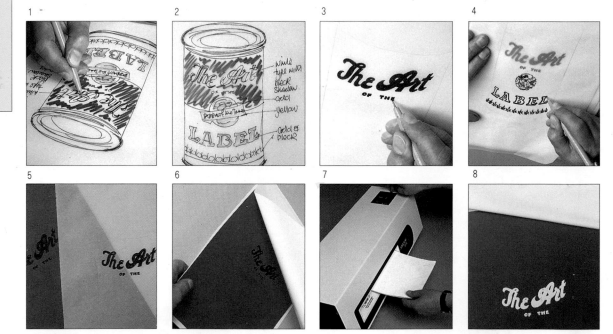

1

2

3

4

5

6

7

8

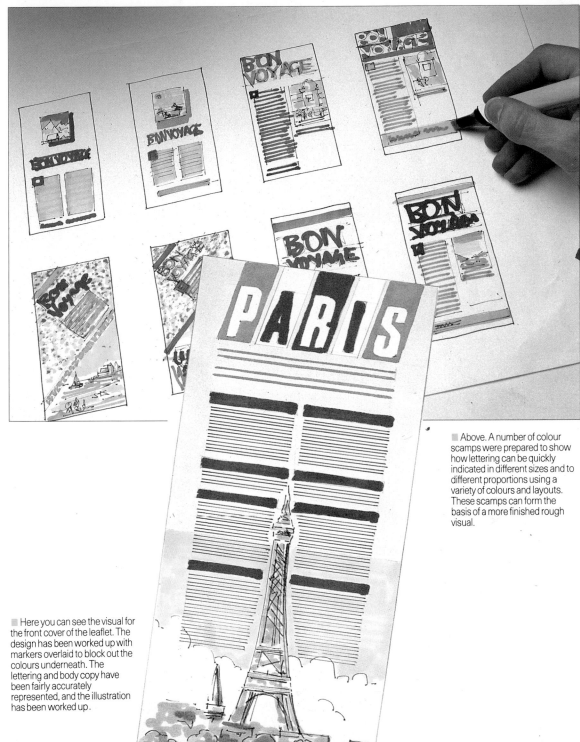

The Omnicrom process allows you to give your rough visual a smart, finished appearance.

1. and 2. Decide on the elements and colours for the visual. The process can transfer any element to any colour, but here we will see how to transfer the words "The Art" onto a solid red background. Eventually, all the elements can be produced using the process.

3. and 4. All the elements – in this case just the lettering – must be drawn separately in black and photocopied.

5. The lettering for "The Art" has been photocopied onto red paper using the original tracing, but the specification is for it to be reversed out of the red with a tiny shadow of black along the bottom edges of the letters.

6. The photocopy is sandwiched between the two layers of Omnicrom transfer paper – a backing sheet and, on top, a transfer sheet, which is available in a wide range of colours.

7. The sheets are fed through the machine, which transfers the colour to the black photocopied lettering. The process can be repeated for many different colours.

8. You can see how the white has been transferred from the sheet of Omnicrom paper to the surface of the photocopy. The black dropped shadow can be added with a fine liner pen.

Above. A number of colour scamps were prepared to show how lettering can be quickly indicated in different sizes and to different proportions using a variety of colours and layouts. These scamps can form the basis of a more finished rough visual.

Here you can see the visual for the front cover of the leaflet. The design has been worked up with markers overlaid to block out the colours underneath. The lettering and body copy have been fairly accurately represented, and the illustration has been worked up.

Rendering black and white photographs using markers

CHECKLIST

- Select a range of thick and thin grey markers.
- Choose either a warm or cool grey range.
- Do not mix the ranges.
- Try working from existing photographs first.
- Draw up your subject lightly in pencil.
- Apply the lightest grey areas first.
- Overlay to darken the tone.
- Create highlights and lighten areas that are dark with a white pencil or white gouache.
- Try inventing a photographic setup.
- Cut out visual references to help in this construction.

The first consideration for scamping and roughing out visuals of black and white photographs is the range of media you will need for this work. There will be no shortage of these as many professional markers are produced solely for this purpose. You will find your graphics supplier stocks an extensive range of greys in various thicknesses, as well as the fine-line varieties. However, I would suggest that you need only two or three greys in the initial stages – ie, scamping – as the intention will be to capture the essence of the photographic subject without any attention to detail.

The grey markers are available in both cool and warm shades. Which you use will be up to you, as the warm range appears a pinky-grey colour and the cool range tends more to a cold blue effect.

As far as the photographs themselves are concerned, you will have two separate approaches to consider. Sometimes the photography will already exist, which means that you can experiment with the actual image that will appear in the visual. Alternatively, you may have to originate what is to be photographed. This naturally requires more illustrative skills, although references can always be sought from existing print.

On the scamp you should experiment with the shape or size of the image, using simple lines and hints of grey. At this stage you can do many things with a photograph; you can eliminate the background, block out areas with tints, highlight other areas with white and so on. The next step is a more accurate interpretation for your rough visual. If the photograph already exists, it is easy to copy the essential visual elements and draw them up either directly onto the visual or as a separate piece of work to be pasted on later. Use pencil, remembering that the lines will show up through the marker, to draw the elements. By referring to the earlier exercises where you overlaid a single colour to create a darker one, you can vary the grey tones, gradually building up a picture with the overlays of tone. Highlights can be added to the final piece with a white pencil or with gouache mixed to a drying consistency applied with a sable brush.

When the visual you produce forms the basis of a photograph yet to be taken, give careful consideration to what will be possible for the final piece, but bear in mind that modern photography allows scope for creative flexibility.

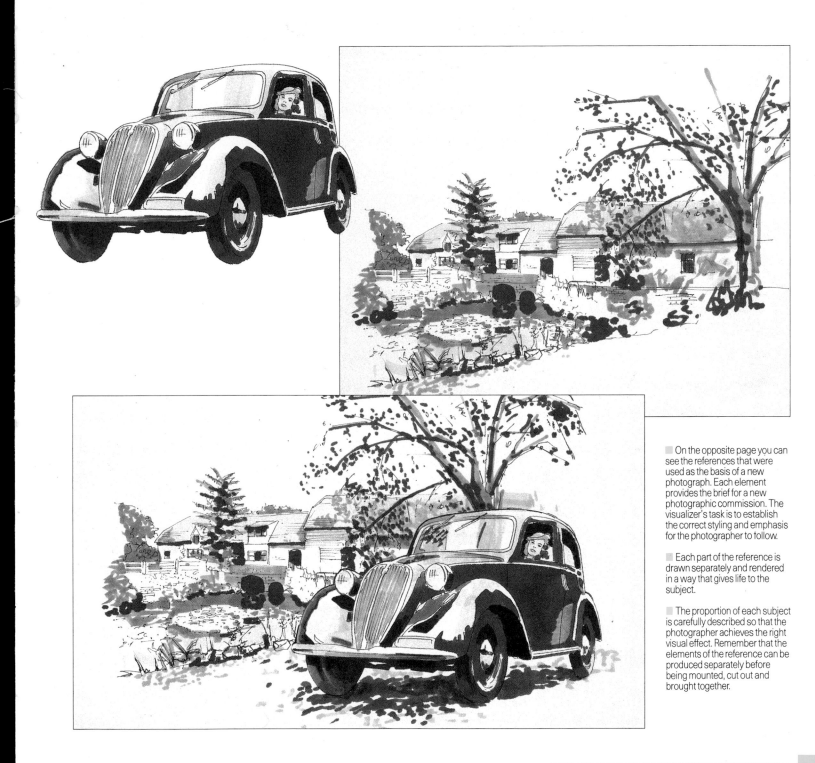

On the opposite page you can see the references that were used as the basis of a new photograph. Each element provides the brief for a new photographic commission. The visualizer's task is to establish the correct styling and emphasis for the photographer to follow.

Each part of the reference is drawn separately and rendered in a way that gives life to the subject.

The proportion of each subject is carefully described so that the photographer achieves the right visual effect. Remember that the elements of the reference can be produced separately before being mounted, cut out and brought together.

Rendering photographs in colour

CHECKLIST

- Become familiar with the styles of certain photographers.
- Analyse their distinctive trademarks.
- Imitate these by depicting their characteristics.
- Imitate the style and composition of their work.
- Pick up the actual colours that are prominent.
- Choose your markers carefully.
- Adjust your style to that of the images created by the photographer.

The images of colour photography can be as varied as the images created by fine artists. The control of lights, film exposures, styling and finally the developing are all highly specialized art forms. Whatever you wish to create within the realms of physical reality is certainly likely to be possible. Photographers are commissioned for a job on the basis of their individual creativity and the style of image they produce.

The visual guidelines of the concept that you are working on will already have been clearly laid down. There will be a clearly defined idea of what image is appropriate to the design.

The visualization of the proposed photographic image must, therefore, be highly skilled and creative. Not only must the visualization imitate the image of the photography – which may well not even exist – but it must also set the tone for the whole of the piece of design. In short, your visual will imply and imitate a photographic image that has yet to be taken.

The first decision to be made is the arrangement and composition of those images. All photographers have a distinguishing trademark to their work. For instance, a subtle tint of blue may always be apparent in the background; the images may be sharp or hazy, soft focus or hard focus, glossy, rustic or with sharp edges. Whatever the concept demands, this will need to be translated in the visual, but to depict the essence of the photographic image you need only hint at the style, colour and forms that are likely to be produced in the final image.

To achieve this, it is essential to select coloured markers carefully. The style in which they are used will demand careful thought. For example, the sharp-edge style will probably rely on nicely gradated and reflective surfaces, whereas the soft focus forms could well be indicated by daubs of impressionistic colour.

Remember, you are only going to hint at the subject at this stage. What is needed is a fast, loose, confident visual.

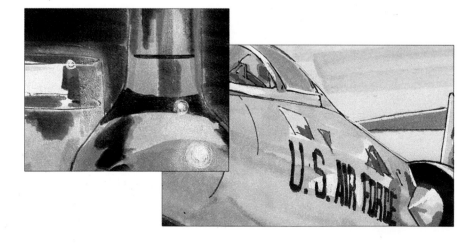

These close-ups of details show the subtle differences between a sharp, hard-edged image (the aircraft) and a looser, softer impression (the bottle). Adding white pastel to the edges of the drawing gives the impression of soft focus.

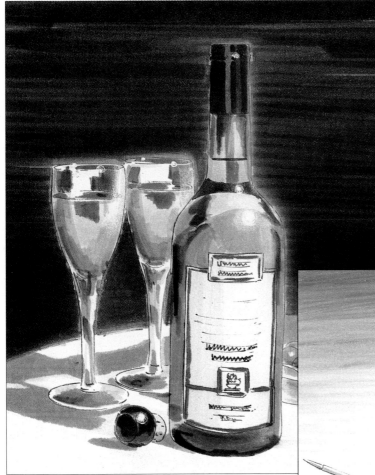

■ This blueprint gives the photographer an exact brief for the position and lighting required for the glasses and bottle. He will know that the photograph he takes must convey the same warmth and appeal.

■ The photograph of the aircraft has been styled to show off its sleek and menacing form. The drawing accurately indicates the position of the subject and the weather conditions that were required. Remember that the photographer will follow exactly the visual brief you give him; always prepare it with the utmost care.

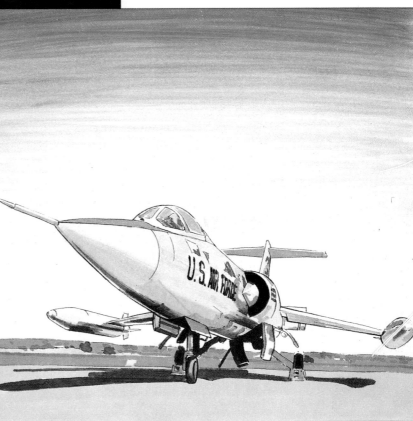

Rendering illustrations in rough form

The flexibility of illustration gives you a scope and freedom that can be quite daunting. Illustration is probably more distinctive and influential in the design than any other visual element, because it is so individual in its creation. It could be anything from an 18th-century woodcut style to a modernistic arrangement of shapes. In the early stages of the design, a hint of the style and form of the illustrations to be used should begin to emerge, and whatever has been determined by the demands of the concept, it is your job to convey this in your visual.

Sometimes, some experimentation in your method will be necessary: you may have to make some kind of stencil; you may have to cut an image from foam and daub it onto the surface of your visual; you may have to paint on one image and press this onto the visual, using inks or gouache. You cannot rely wholly on markers and drawing to create the image.

Do bear in mind, however, that your task is to create and indicate an image in your visual; it is the task of your chosen illustrator to create the finished concept.

You need to make careful note of which illustrators are available and the styles they use. You should be using their style to imply the image you want, although they themselves will eventually be giving life and interpretation to what finally emerges.

You can have a great deal of fun experimenting with illustration because the number of images possible is infinite. Use any medium you wish and experiment with whatever is available. Try inks, pastels, coloured pencils, bleach on ink and gouache as a form of resist. Continue experimenting and mixing with whatever comes to hand.

Finally, always ensure that your visual is a close reference to what is eventually to appear.

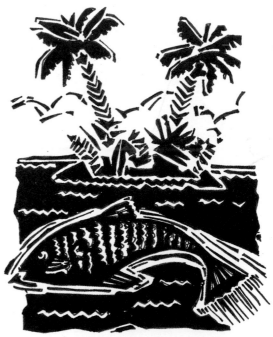

■ This black and white illustration imitates the woodcut or linocut process. You can quickly produce an illustration that resembles the process by working over black permanent ink with white gouache paint. Achieve the chisel effect by using a brush with a chisel point.

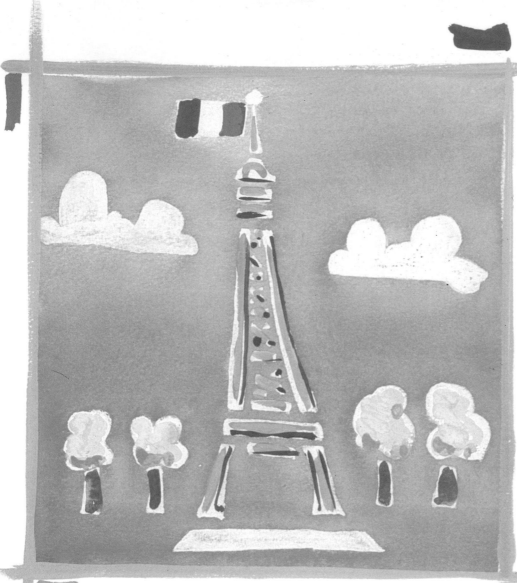

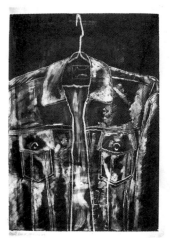

■ The drawing of the jacket was produced by completely covering the surface area with water-soluble ink. When this was dry, a brush was used to apply bleach, at different degrees of strength, to give the drawing tone and form.

■ Below. The drawing of the warehouse was created by using a medium marker on heavy watercolour paper, which gave a textured look to a simple line drawing.

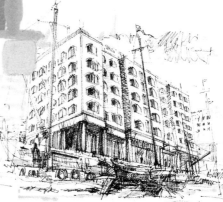

■ This illustration uses the gouache-resist process. Areas of the illustration were blocked out with gouache paint. When the paint was dry, a wash of coloured permanent ink was added over the picture area, and when this was dry, the paper was held under a tap so that the areas of gouache could be carefully washed away. Paint was used to bring the areas of white to life. This method can be used to create both loose and highly complex illustrations.

Marker roughs: visuals of type and photographs

When you are dealing with photographs and type, the first consideration must be that these two elements offer different images. The concept itself must dictate the parameters within which you will work. For instance, if you were portraying a period in history through your design, the type style chosen must be in keeping with the period and the style of the photographic image will be designed to reflect this as well. The other extreme of this would be photographic images of high technology or modernistic subjectivity, which would require a balance of type image of a complementary nature.

If you have to bring together these two images, you will be faced with another exciting creative problem, and you will have to experiment with the compositional arrangement. The first problem is to decide on a number of alternative arrangements for the size of the type and of the photograph. The next consideration will, logically, be the shape the type makes or the shape of the photograph, bearing in mind that you can soften the edges of the photographs, white out backgrounds, alter the coloration, print in just a light tone underneath the type or reproduce solely as line images. These are just a few of the ways in which you can merge images into the design to give them their own individuality.

Always remember that in the initial stages you will be producing a thumbnail sketch that will explore the idea you have in mind. Initially, in your thumbnails, you will merely be indicating a balance of the visual tones that will appear on the surface of the design. Different weights of text will be indicated by different shades of grey or colour in notation form. The photographs, or style that will be implied, should only be hinted at. It is the balance between the two elements – type and photographs – that you are exploring at this stage.

■ The thumbnail sketches shown here were produced in pencil. They tonally depict the photographic and typographic elements as an initial idea for the marker visual that is to be created.

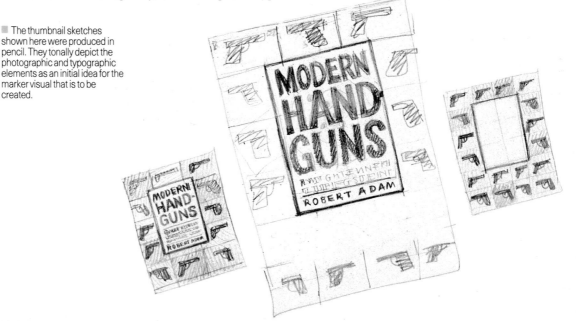

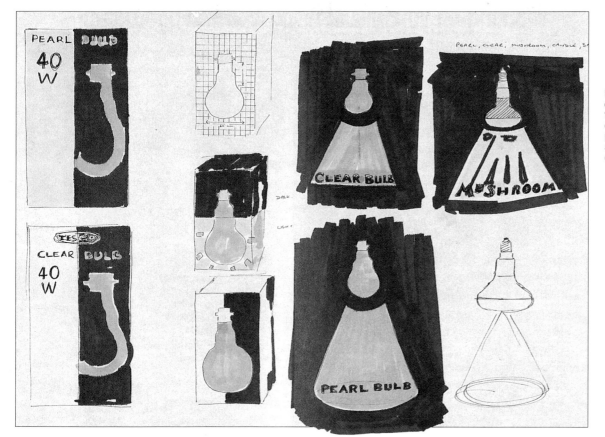

These packaging visuals describe the photographic and typographic elements as simple coloured forms. The styling and photographic technique to be applied will be investigated as the design develops.

This page gives a proportional and styling quality to the photographic elements and can be used as the basis for the costumes and model to be used. The creation of the photographic image will be the responsibility of the photographer you have chosen.

Marker roughs: visuals of type and illustrations

Illustrations pose different and distinctive problems for the visualizer. When a design is conceived, some images will be suitable for the brief, and these will be realized in the form of the work of a particular illustrator or illustrators whose style is in keeping with the initial concept. First, therefore, you will need to have some knowledge of the illustrators who are available commercially and of the cost of using their services. A quick phone call to the illustrator or his agent will soon establish his suitability and availability for the commission. Having decided on some possible illustrative styles, the task now is to interpret these styles into the images that are going to be included in your rough visual. Once again, you will have to tackle the problem of complementing the other elements with this illustrative work, as well as reflecting the correct image and style for the work in hand.

Remember that, although you are choosing an illustrator for his particular style, you are going to dictate how those images are to be projected. For instance, you may choose an illustrator who normally works in black and white but your design dictates that colour will have to be used. You may, therefore, commission a black and white illustration

that will be printed in colour. Alternatively, your illustration may need to fit a particular shape in the design or complement a particular style of type image. You would therefore expect the illustrator to be flexible in his commercial approach to the design in hand.

The next major task is quickly to establish the illustrative images with the typefaces through a series of experimental sketches. As you have some reference of the illustrators in whom you are interested and the typefaces you indicate will bear some resemblance to the typefaces that are appropriate, you need produce little more than a notation or shorthand of the elements. This is also an opportunity for you to change the size and proportions of the elements in your rough.

The quickest way of establishing these scamps is with marker pens. Even if this medium is not complementary to the illustrator's method of working, bear in mind that your concern at this stage is only with the arrangement of the elements.

These scamps rely heavily on a strong illustrative style to project the concept of the poster. The initial thumbnails have been quickly arranged to give a mood to the subject in hand. A distinctive illustrative style is emerging and this can be developed later and discussed with the chosen illustrator.

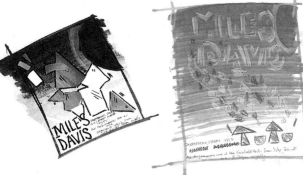

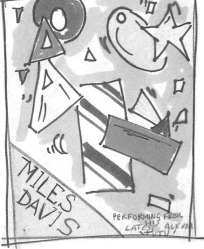

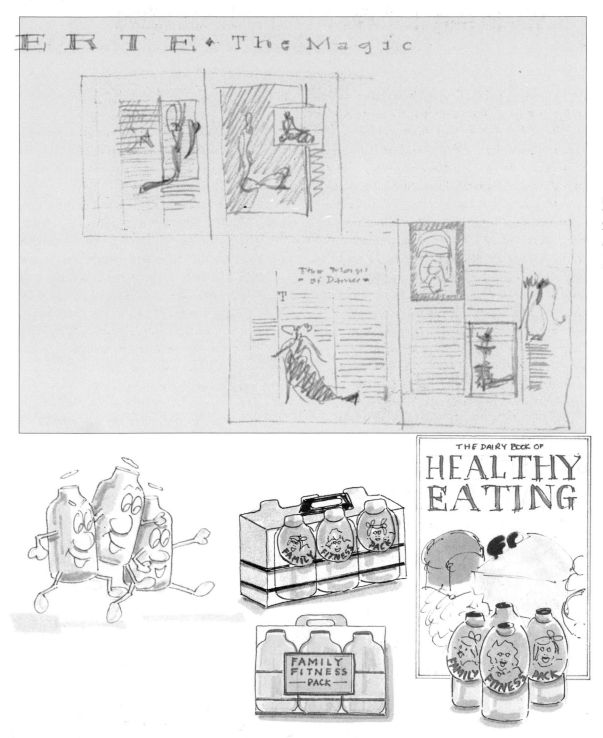

■ The thumbnails of these page layouts mix a distinctive typographic styling with the grandeur of the historic subject. The illustrations hint at the style of Erté, which is all that is necessary in these initial sketches.

■ These marker visuals give a strong and commercial flavour. They depict a general, mass-produced styling that is relevant for the illustration, typography and design required.

Working up your visual using type and illustrations

The scamps now form the visual plans for the greater development of the idea. By extracting the idea or ideas that you feel would work up into visuals that will constitute the designs that fulfil the brief, the major task is complete. The hard work and deep thinking are probably over as you are on target for the client's requirements. This leaves you with the pleasant job of interpreting the scamped ideas into visually satisfying, sparkling images.

The type needs to reflect the style that has been selected. The colours must be carefully thought out and matched and the illustrations rendered in a style sympathetic to the eventual work of the illustrator.

All this work may need to be pieced together as separate elements as each may have to be produced in a variety of media. For example, the major background colours and textures may be implied with marker, the lettering could also be produced in marker but could just as well be painted as reverse images using gouache paint, and the illustration may require any number of special treatments.

In conclusion, you are still giving only an impression of the final piece, but with as much accuracy as time will permit. I cannot stress enough the importance of being time conscious in the preparation of your rough visuals.

This double-page spread, seen as a scamp on the previous page, has been developed to a more finished state. The style of the typography is apparent, and the actual illustrations are clear and precise. This combination should be sufficient to make a decision on the design.

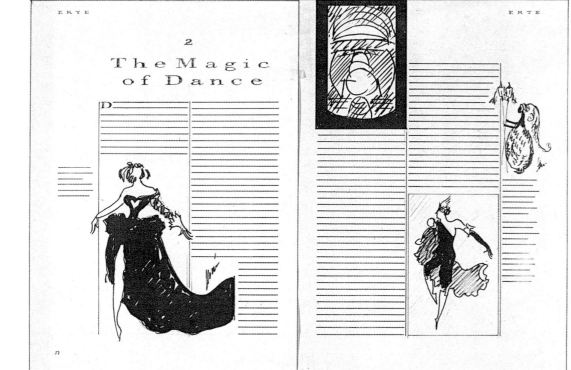

THE DAIRY BOOK OF
HEALTHY EATING

■ These marker visuals, which you saw in their initial stages on the previous page, have been developed to identify an actual style. It is possible to see that the illustrations could be quite simply a further development of marker illustration.

FAMILY
FITNESS
PACK

■ Children's books are a delightful area for design work, and one in which illustration and type can be combined. Expressive and simple illustration, produced in effective media, are all that is required for an acceptable product. These charming illustrations are produced first in line, then worked up with a technique of gouache applied in a distinctive way.

CHECKLIST

■ Become familiar with a variety of illustrative styles.

■ Get to know some illustrators.

■ Bear in mind that the style of work will be influenced by the illustrations used.

■ Remember that the elements must suit the whole design.

■ Choose typefaces with care.

■ Experiment loosely, unevenly indicating the elements.

■ Adjust size and proportion to achieve different effects.

■ Select appropriate ideas from the work you have produced.

■ Check these against the brief.

■ Indicate the elements more accurately.

■ Introduce other media to create your effects.

■ Consider colour, tones and shapes.

■ Exercise control over the way the illustration is presented and the way in which the final image appears.

■ Be cost conscious with your time.

Alternative layouts

The process of developing a concept in the initial stages is quick and exhilarating, and you can achieve much in a short space of time. If the visualizer could work through all stages of his visual in this way, there would be no need to find alternative ways to keep the visuals fresh and exciting. However, the processes involved gradually become more time consuming as the work evolves: the colour must be applied more carefully; the type images must be more recognizable; and the illustrations and photographs have to be closer to what is finally to be produced. Alternative layouts will often be a re-sorting of the elements in different proportions, compositions, colours and tones. It is at this point when the fine tuning of the idea becomes the goal.

These layouts will be produced with speed to an accurate proportional size of the finished piece. There will now be no variation in size or proportion of each layout, and the elements will have to be produced accurately to fit the layout idea.

The techniques used in producing these visuals are very straightforward. Each of the design elements will be drawn on a separate sheet of layout paper or produced in some other way. The first sheet of layout paper will be the outline of the shape. The different elements are then offered up underneath this sheet, and when the position is visually correct it can be traced in place. Remember, any background colours must be filled in before you make a trace. The process will have to be carried out for every part of your layout. As you will now realize, it does involve some time-consuming work, but you should still be working as quickly as possible.

■ Each of three initial sketches depicting the ice-cream cone retains a quality of its own. Any one can be developed further. The decision will depend on whether the style or effect needs to be changed or whether they can remain as the basis for the rough visual design.

Shapes and colours can be experimented with to vary the effect. Each of these further ideas will form the basis of the selection process and could be included in the final visual process.

Two alternative notions have been created here for different products in the client's range. The style of visual is retained, while the emphasis on the balance between illustration and type image has been varied to project a different image.

Alternative layouts using other media

You will now have at least one master visual. You will also have produced the elements for this layout from separate sources, and you now have the option to produce further layouts with mechanical aids. The first of these, which is becoming more and more popular in graphic design studios, is the photocopier, and you should be able to create many of the stages of the visual simply by using the enlarging and reducing facility. Even some standard machines have a limited use of colour. The over-photocopying process allows you to collage images together into one final visual, and this can then be coloured or tinted using a variety of media, and you should experiment to see what is possible. These photocopies could also be used as masters for you to trace off the elements. Alternatively they could be used as the basis for another process, namely, the making of Omnicrom prints. This process is not used so often in making rough visuals as it is closer in the mechanical make-up to more finished work. Omnicrom is a brand-named machine that will produce coloured images from black photocopies, a process that is achieved by placing a sheet of colour film together with the original through a set of rollers. The black image creates a stencil, and a duplicate in colour emerges from the machine. This process can be repeated several times to produce a piece of work in several colours.

Finally, it is worth remembering that colour photocopying can be used in making alternative roughs in different proportions.

■ Images can be simply produced in black and white, photocopies can be taken, pieces of these copies can be cut away, new text can be added, and the whole design can then be re-photocopied. Once the drawing has been produced and photocopies made, these can be used to produce colour visuals.

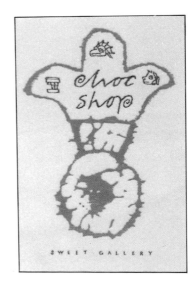

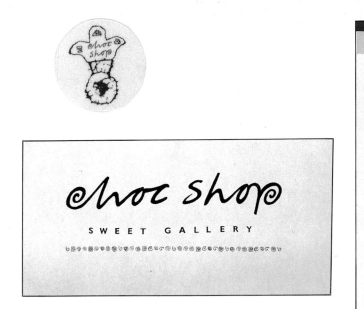

The design in the top right-hand corner makes use of another method of visualization. Tissue paper is overlaid to create subtle and effective colour variations, a method of working that is suitable and effective for a project of this kind.

The remaining visuals on this page have been created to a very high standard using the Omnicrom process.

CHECKLIST

■ Work out the size of the design area in proportion to the finished piece.

■ Draw this shape in pencil on a sheet of layout paper.

■ Draw the lettering in proportion on a separate sheet.

■ Repeat this process with the other elements.

■ Place any background colours on the first sheet.

■ Place the elements underneath.

■ Render them in position.

■ Use the same elements to produce alternative compositions.

■ Enlarge and reduce the elements using a photocopier.

■ Collage these together and get them re-photocopied.

■ Colour up the photocopies or use them as the basis for new visuals.

■ If it is available, experiment with the Omnicrom process.

■ Use colour photocopies to add another dimension to your work.

CHECKLIST

- Organize the scamps together.
- Cut them close to the design area.
- Mount these together, allowing space between each design.
- Select those scamps that can be worked up.
- Make larger, more carefully produced layouts.
- Use these layouts as a basis for discussion with your client.

Organizing the scamps together will benefit both you and your client. You will be able to get an overview of all the alternatives mounted together so that they can be viewed at a glance. You could do this by cutting each of the scamps from the pages they have been drawn on, keeping close to the design shape, and then spray-gluing them on the underside and mounting them in neat rows on heavy cartridge paper. The selected scamps could then be worked up to visual stage to see how each design would work individually. Each of the designs would show a potential that suited the brief but communicated the visual message with a different ambience.

Although there is enough information in each of the visuals to satisfy the design brief, and maybe even to make a final decision, more often than not the client and designer will use these as the basis for further development. Each of the designs will have features that will be of interest to the client, and it is the designer's job to discuss with the client how these features can be retained in a single design.

■ It is important to show a number of styles and ideas that will be included in the design. The client can be shown these to give him an idea of how the work is progressing, and he can also be involved in the decision-making process. This will help him to make the final decisions more easily.

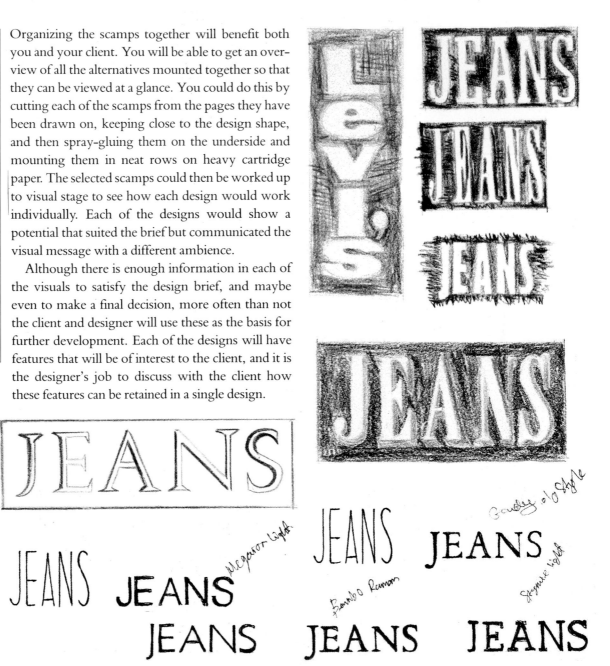

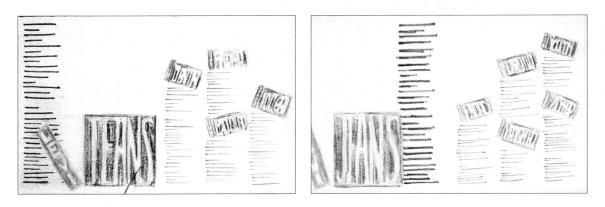

As the design develops you should be thinking of alternative ways of using the selected elements. These can be arranged and re-arranged to give a different style, emphasis and meaning to the layout. It is wise to show the client a good selection of these, giving him enough variety to enable you to progress with the work.

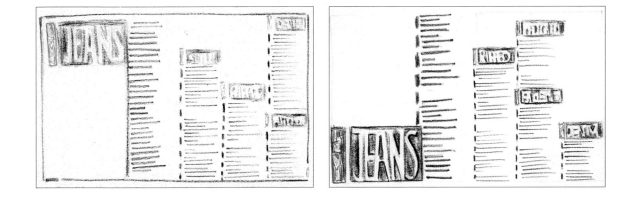

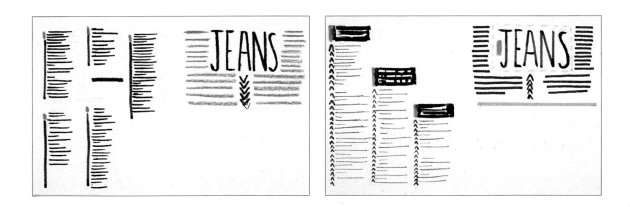

Finished rough visual

CHECKLIST

- ■ Assess the client's response to the rough visuals.
- ■ Extract the key features for reinterpretation.
- ■ Discern the level of presentation required from your meeting.
- ■ Create a visual to the standard your client requests.
- ■ Mount the visual on quality board to give it greater presence.
- ■ Allow large white margins around your visual.

You will now have a clear idea of the client's preferences and the way he sees the job developing. By discussing the roughs with him and monitoring his response to the images displayed, you are now able to apply this information to what will, you hope, be the definitive design. Depending on the client's response to visuals – he may understand a quick rough indication of the idea, or may require much more detail to interpret what you have in mind – you will know how much work is needed to produce this final visual.

If it is clear that an understanding has been reached in earlier presentations of this work, it is likely that the standard already produced will be acceptable. If, on the other hand, you have had to spend some time explaining each feature of the designs, it is obvious that your client requires the work to be produced to a highly finished standard.

Many levels of quality can be attained in the production of finished roughs. The highest level is a mechanical make-up of all the visual elements as finished pieces. This is when the photography has been taken or an extremely real-looking visual has been produced. This would also apply to an illustration. The text and headings can be typeset and photographed onto a cell to overlay onto the design area. The colours can be cut out from sheets of PANTONE colour paper or airbrushed into position.

This is an expensive procedure as it requires many specialist processes which take time to complete. Normally you would be able to work your visual up by hand, rendering all the elements together. The final touch will depend on how neatly and how well presented your piece of work appears. Always mount each visual on substantial, white mounting board, allowing a large frame around the edges. This not only gives a power and strength to the work but also accentuates the quality in an eye-catching and professional manner.

■ The elements for the design have now been clearly defined. All that will remain for you to do is to finalize any further details in preparation and as fine tuning for the visual you intend to present. Even the media in which the visuals are going to be produced to best effect should be tested and tried before moving on to the final piece.

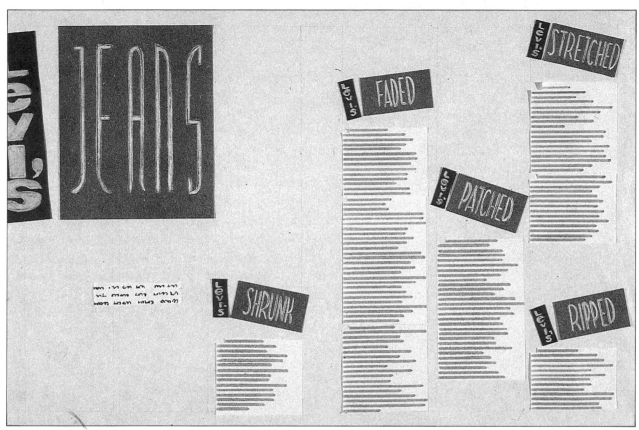

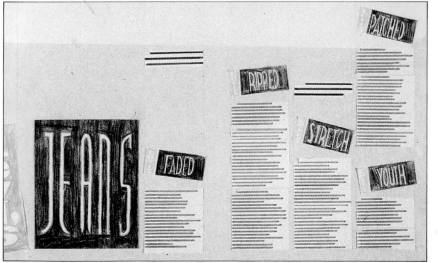

When you have reached the next agreed phase, a visual can be created for the client. This should embody all the best features of the previous studies and visual stages. Decisions on the techniques to be used to produce this visual should be made, and an accurate, but slick representation of type, design and photographic or illustrative elements should be rendered.

Rough visuals to artwork

There must be some restrictions with every piece of creative work, even if only to moderate the ideas you would like to generate. Remember that, at some stage, your visual will be translated into artwork for the preparation of the final print. Although the modern printing methods now available allow almost anything to be reproduced, the cost of an ill-considered design could easily go way beyond the budget allowed. How the final artwork is going to be made and the number of colours required in the print process must, therefore, be considered, even at the scamp stage. The visual must also reflect what is possible and affordable in the artwork make-up.

For instance, if you decide that your design requires special letter forms that are not available in standard typesetting or are not modifiable by the tricks that can be played on modern type using high technology equipment, hand lettering may be necessary. This is a specialist job and will add cost to the design.

Modifications can be made to photographs, some of which can be done cheaply at the printers, but special tints, effects and changes in coloration or construction may need the expert skills of the photographic re-toucher – again an expensive addition.

Finally, unless the colours you use can be reproduced from the printers' standard four colour set, you may incur additional print runs of colour, which once again will add to the cost. You may need to consult with the artist of the finished work and with the printer as the work evolves.

■ The designs shown right and opposite, above, are elaborate and clearly the visualizer had few restrictions, either imaginative or financial. In contrast the simplicity of the design and the visual shown below, opposite, reflects the down-to-earth targetting for the brochure.

■ The initial stage in the process leading to artwork is the creation of the first visual. The example seen here has been produced by collaging existing letter forms, typography and pictures.

This double-page visual was produced by the technique we saw on the previous page but with the added assistance of a photocopier, which was used to produce the large letter forms. If the right pictorial material is readily available, collage is a good method of creating visuals.

The visual for the Miners' brochure was created using the Omnicrom process. The magazine that is featured on the cover is a reduced photocopy with a coloured, cut-out inset to make it look like the real thing.

Colour visuals and print

Although the visual has been approved and the artwork drawn up ready for the printer, this is not the end of making visuals. As most artwork is made on one board (this is known as flat artwork) and is overlaid with an indication of the areas that the colour or tones will fill, a form of visual needs to be produced to match the areas of colour, tone or special treatment that will be carried out by the printer. When the artwork has been completed, proof checked and corrected, it would normally come back to the designer for this final touch. He will carefully fill in the areas of colour using a bleed-proof overlay. This overlay will carry not only the visual information but also any special instructions, which should be written clearly, for the printer to follow. Specifying colour has been made easy over the years, because the PANTONE colour system, which relates to the markers and to the inks that printers use, can now be either noted with a simple code number or torn from a specially prepared swatch which is attached to the artwork, or both. In this way it is possible to guarantee that the final effect of the printed piece bears a direct visual relationship to the original rough.

So that you can make a final check on the colours you specified for the printed work, it is always advisable to see a proof of the print. Keep your visuals so that you can compare them with the proof. You can easily tell the printer to change the colours before he sets up his production run.

■ Here you can see a typical piece of flat artwork. Large areas of the design which the designer wishes to be printed as a tint appear solid red on the artwork: this is an adhesive film which the printer uses as a positive image area.

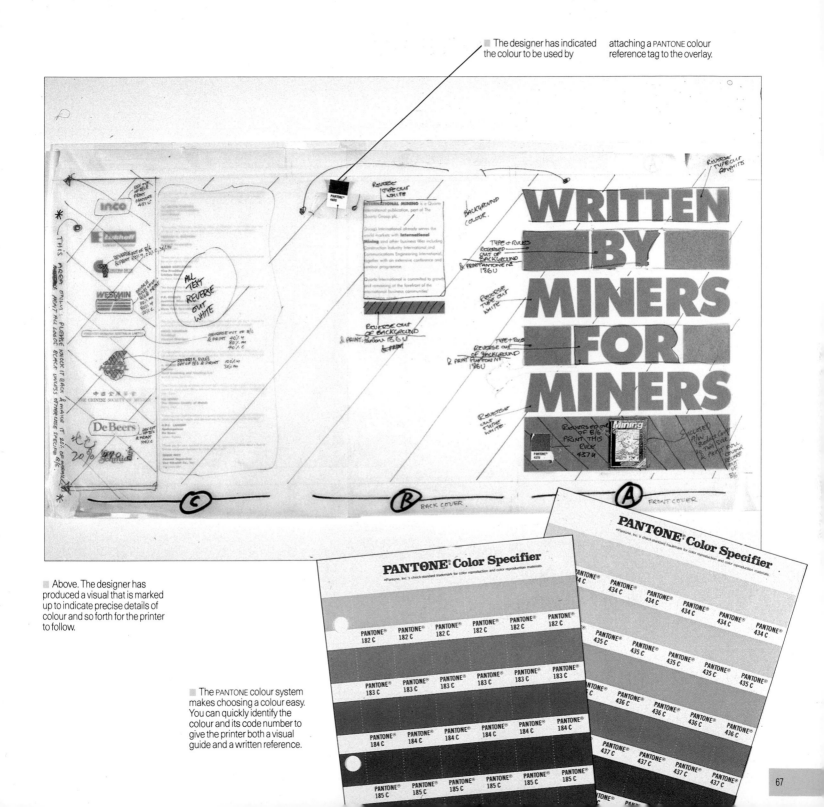

■ The designer has indicated the colour to be used by attaching a PANTONE colour reference tag to the overlay.

■ Above. The designer has produced a visual that is marked up to indicate precise details of colour and so forth for the printer to follow.

■ The PANTONE colour system makes choosing a colour easy. You can quickly identify the colour and its code number to give the printer both a visual guide and a written reference.

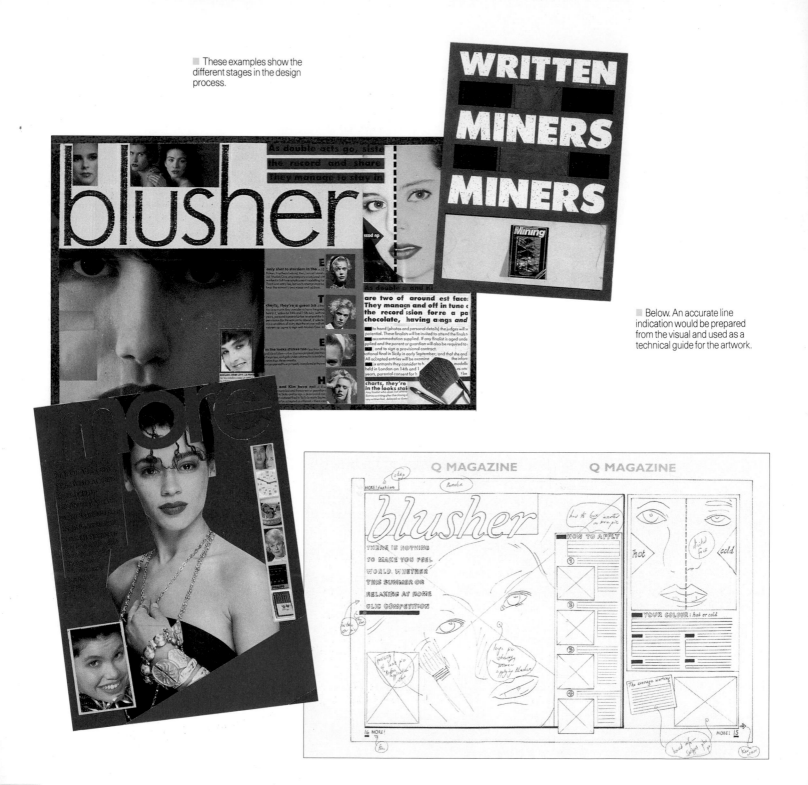

■ These examples show the different stages in the design process.

■ Below. An accurate line indication would be prepared from the visual and used as a technical guide for the artwork.

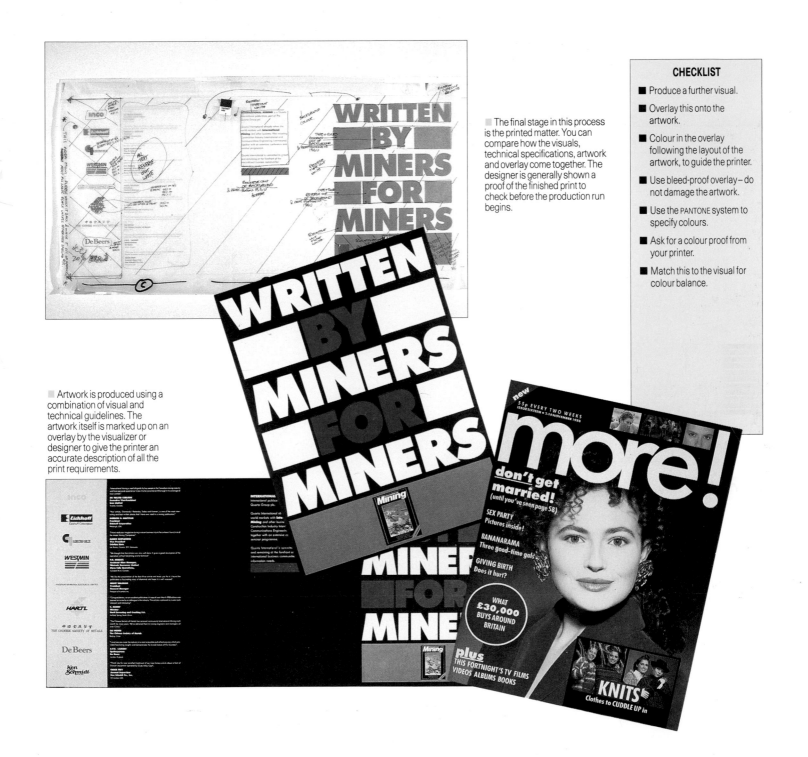

The final stage in this process is the printed matter. You can compare how the visuals, technical specifications, artwork and overlay come together. The designer is generally shown a proof of the finished print to check before the production run begins.

Artwork is produced using a combination of visual and technical guidelines. The artwork itself is marked up on an overlay by the visualizer or designer to give the printer an accurate description of all the print requirements.

CHECKLIST

- Produce a further visual.
- Overlay this onto the artwork.
- Colour in the overlay following the layout of the artwork, to guide the printer.
- Use bleed-proof overlay – do not damage the artwork.
- Use the PANTONE system to specify colours.
- Ask for a colour proof from your printer.
- Match this to the visual for colour balance.

TECHNIQUES OF VISUALIZATION

EACH AREA OF THE GRAPHIC DESIGN INDUSTRY uses a different approach to producing visuals, and within each area formulae have emerged to solve the problems of creating original ideas through the visualization process. There are, for instance, marked differences between the approach adopted by advertising agencies and that used by design consultancy companies. The way visualization is used also differs between these two areas of design.

Over the years advertising agencies have separated the operations employed in the creative and reprographic areas to such an extent that a visualizer, working for advertisers, can become something of a star. The demand for his services can become quite competitive, and he may exercise his understanding of trends in this business combined with a high degree of slick skills in a freelance capacity for a number of companies.

The advertising visualizer is an interpreter of ideas. These ideas will be created within the agency by the copywriter and art director, whose job it is to arrive at a concept that communicates both visually and verbally the message that will promote the client's product. But however creative these two people are, they still rely on the skills of others to interpret their ideas and concepts visually.

Visualizers working in this area are expected to be highly expert in the techniques of using markers.

They are often required to understand a simple scribble of an idea, which they then have to interpret and bring to life through realistically drawn photographs and illustrations. They must be able to flick in headings and copy with the single stroke of a marker. The emphasis is on speed, flair and attractive eye-catching marker visuals. The final visual, produced solely in markers must also represent the area of advertising for which it is intended, such as the stages of a television commercial or a static newspaper advertisement.

There is a great difference between the methods employed in the design consultancy and those used in the agency world. Quite often the designer in consultancy companies, whose equivalent is the art director, is responsible for the entire design process. He or she will not only arrive at the concept but will also frequently take the work through all the visual stages. His or her skills must encompass both the ideas and the techniques employed in their visualization. As the designer is also the interpreter, the method employed in the visualization process is often more varied than just markers. He or she may decide that a job would be better produced in visual form using coloured cut-out papers or any combination of media that he or she has previously used with skill and success. The interpretation of the concepts may require a broader understanding of

visual elements and greater interpretative skills combined with an ability not only to present the idea and its elements but also to imply the textural qualities, the input of illustrations, the photographic effects and, where necessary, the three-dimensional aspects of the design.

In short, while the advertising visualizer implies a slick impression of the concept, the design visualizer gives life to the design by producing a close representation of its final form.

These two areas, advertising and design consultancy, are the two extremes. This section of the book will look at the work of many professionals and techniques they use to create rough visuals. In addition to the areas mentioned, I shall give visual examples of the work produced in a number of other graphic design areas.

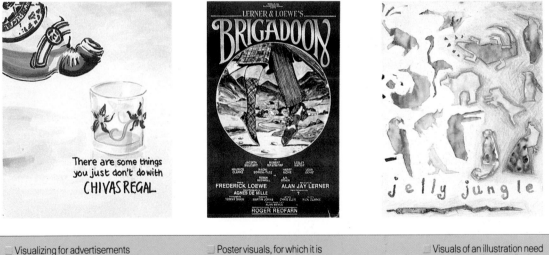

Visualizing for advertisements is normally done with marker pens. This is a typical example of a rough visual produced during the creation of an advertisement.

Poster visuals, for which it is important to show the typographic elements accurately and in the correct proportions, demand careful treatment and high standards of visualization.

Visuals of an illustration need to reflect the style of the final image. The media used in this process can vary from project to project depending on the image sought.

Advertising visualization

Miami Valley Hospital The Region's Leader

When the subject requires the display of a number of elements, a quick thumbnail sketch can establish their priorities. However, a highly finished piece of work will have to be produced to present the information in a convincing way.

Billboards and posters

Billboard advertising serves both national and regional needs. For example, some national companies, organizations and political parties have discovered the power of large format billboard advertising. These organizations use this medium in both a teasing and direct way. The essence of good advertising is to communicate a message by using forceful visuals and giving direct information. The visualizer must take into account that the audience is likely to be on the move, in a hurry and uninterested in attempts to capture their attention. Therefore, the elements that go into the design must be considered carefully to give priority to the main features of the concept.

Billboard advertising is used also on a regional basis, and it is a good platform for achieving the visual saturation of a local community, where a more personalized message can be communicated. The medium can also be used to attract people who are travelling into the locality and to inform them of local entertainments or services.

Apart from the larger poster displays, there are many smaller sites that display posters of various sizes. There are also display areas on buses and trains as well as by the side of escalators and at stations, airports, post offices and bus stops.

The major consideration in the production of visuals for these areas is the proportions that have been devised. Each of these sites or locations has a set format, the proportions of which are predetermined. So, before starting work, you should establish the exact location for your message. You may even have to contact the bus or train company or the owners of the poster site where the message is to be displayed.

Finally, the visuals you will produce should appear as accurate, proportionally scaled drawings of the actual size. The only format that may be produced to actual size would be the posters to be displayed within buses or trains.

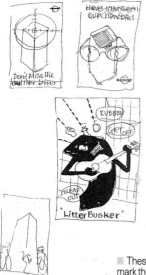

These thumbnail sketches mark the first stage in a long chain of visual developments.

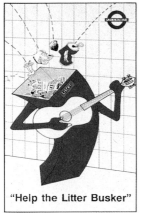

"Help the Litter Busker"

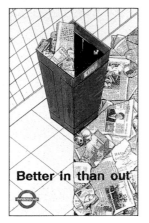

Better in than out

The end of the line for litter

Look out for the new bins

■ From the initial scamps, visuals can be easily established with the swift and accurate use of marker pens. These give shape and form to the ideas, but they must be done accurately and confidently so that each idea is presented with the same degree of strength.

Connections at all stations

■ Presentation roughs are produced from the early visuals. These roughs may show the idea in much more detail and involve the use of more than one medium. The moonlit scene has been airbrushed to give the poster the right visual effect.

Take me to your litter

CHECKLIST

■ Draw up your design area in proportion to the site where it will be displayed.

■ Give priority to the main features of the concept.

■ Remember your audience may be on the move.

■ Differentiate between national and regional requirements.

■ Make sure that the information is readable and attention grabbing.

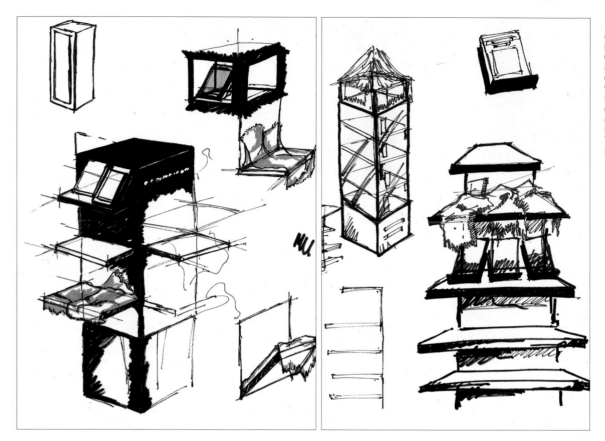

■ A series of initial rough visuals for a display stand exploring the possible options of storing and displaying the product (in this case a range of scarves and shawls). The designer has experimented with varying ideas and perspectives to make a dynamic visual of the 3D objects for discussion with the client. The choice of black gives a high impact and a high class feel. The graphics would be applied at a later stage of presentation.

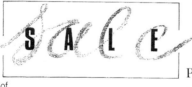

■ Once the idea for a project of this kind is formulated, it is possible to experiment using actual letter forms and tints. These can then be coloured by using the Omnicrom process to give a realistic indication of the concept.

Point-of-sale

Point-of-sale advertising has a special place in the advertising world and comes within the area known as 'below the line' advertising. It is used to communicate information in a simple and sometimes glamorous way at the point where the product is sold – hence its title, point-of-sale advertising. It can be seen as a product display, a hopper display, a shelf strip, a hanging poster, a crowner for attaching to the product, a show card or any manner of display material that is used both in the window display and inside the retail outlet to communicate individual products.

The work may be customized for a single store or business, or it may be mass-produced for a multi-national chain store. Clearly, the money available for this work will be governed by the budgets of the businesses themselves, and this will often influence the type of visual that is produced. For example, display material for, say, a single business is often reproduced by means of silk-screen printing, which can be used to produce cheaply just one or two displays.

With this in mind, the visual that will be produced from the given elements will take into account the way in which the silk-screen processes affect the final image. For instance, you can use the coarse dot screens and the solidity of the opaque inks to create a distinctive and powerful image, photographs and illustrations can be given an interesting, textured look, and display lettering can be given an original treatment.

The other considerations that distinguish this work from other areas are, first, the variety of materials on which the images are reproduced; second, the fact that, more often than not, they are three-dimensional, and third, that a lot of creative thought can go into developing the shape and structure, although other people may need to be consulted about the final construction and material and the best possible display device.

Finally, a loose drawing of the interior of the store and the point-of-sale locations should be produced to give a convincing picture of the display material.

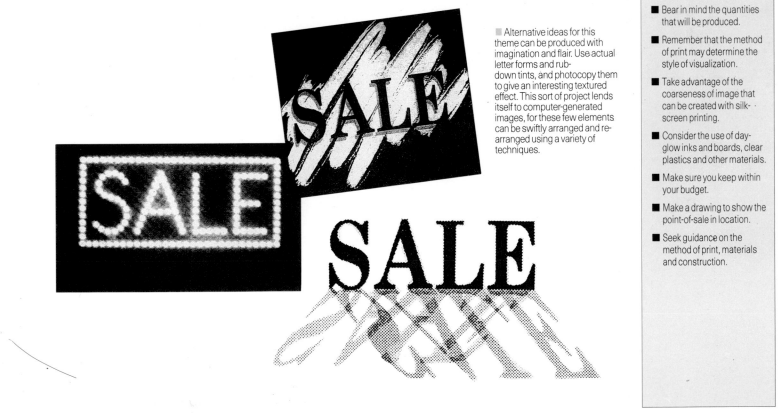

■ Alternative ideas for this theme can be produced with imagination and flair. Use actual letter forms and rub-down tints, and photocopy them to give an interesting textured effect. This sort of project lends itself to computer-generated images, for these few elements can be swiftly arranged and re-arranged using a variety of techniques.

This is the first scamp in the development process of a design for a direct-response insert. The scamp embodies all the necessary information in a loose but precise way.

LEARN TO DRAW
LEARN TO PAINT
FOR PROFIT AND PLEASURE

Most direct-response material requires a coupon, which has to carry vital information and allow sufficient space for a written reply.

Every lesson opens up a new world of pleasure

YOUR FOUR POINT GUARANTEE

15 DAY FREE TRIAL

CHECKLIST

■ Check the specific requirements for the advertisement.

■ Establish the coupon size if necessary.

■ Check the postal specifications.

■ Decide on the element that should be given special emphasis.

■ Research the style of publication for your advertisement.

■ Visualize press ads in markers.

■ Rough out brochures and catalogues using mixed media.

Direct mail, direct response and mail order

This is an area that has enjoyed tremendous growth in recent years. In the past it was widely considered that the actual products being sold through mail order, direct response or direct mail were of dubious quality. But times have changed, and both clients and advertisers have become aware of the potential for selling all manner of quality products and services through specialist press advertising and the use of the post or dispatch companies.

Direct mail is a system that enables the purchaser to pay direct for goods seen in an advertisement, often using the coupon that is included in the advertisement. Direct response invites the potential purchaser to enquire for further details of the products or services. Mail order is a system by which potential purchasers obtain brochures or catalogues of the services or products and then specify their requirements by post or telephone.

All these areas require some specialist approaches to visualization. For instance, the first point of communication for direct mail is most likely to be a press advertisement, although television advertising has now entered the field. These press advertisements demand a specific treatment, for the advertiser must immediately communicate the product or service. This can be done by means of a "screamer", which is a heading that "leaps" out of the page. These advertisements will also probably carry a coupon or a telephone number, and these again must be clearly visible.

The art of direct mail advertising is instant communication, and the same would apply to direct response for which the advertiser requires a name and address to send further details.

Mail order advertisements, on the other hand, often need to show more than one product to give the appearance of a well-stocked store with many products to choose from. These advertisements invite the potential purchaser to pick up the cata-logue or brochure that describes the service or products in greater detail, and the visualizer will be involved in producing roughs for both the press advertisement and the printed brochure.

■ Most mailings these days offer the enquirer a "Freepost" or "Postage Paid" service; it is sensible to seek guidance about the technical specifications for any such response cards. If a special offer is attached to the response, this would normally be referred to throughout the design and not confined to the coupon or order form area.

■ This mailing shot for a book club has been worked up to a slightly higher standard. The visual matter and text are positioned precisely, and the visual has been produced with marker pens and highlighted with white gouache. The dotted line through the centre indicates where the enquirer should detach the order form.

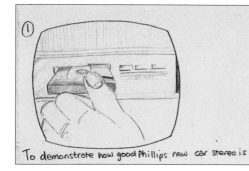

To demonstrate how good Phillips new car stereo is

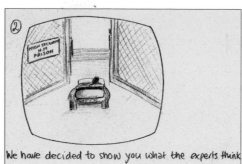

We have decided to show you what the experts think

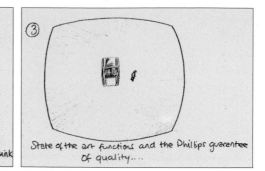

State of the art functions and the Phillips guarentee of quality.....

Storyboards

The main purpose of storyboard visuals is to describe the sequential events of a moving picture advertisement, although the same system can be used to describe audio-visual work as well.

Drawing pads are now available that have ready-made television screen shapes printed on the surface. Below the screen area is space for the script and another space for special effects instructions. The initial concept for the work, which will have been created by the art director/copywriter, will either be loosely indicated on the storyboard pads or simply jotted down on a scrap of paper. Depending on the style of the originators, there may be more emphasis on the visual elements than on the text, or this emphasis could be reversed. You may have to work up your visuals from a written script or from some quick sketches. The important factor is that the sequence of events follows a logical and descriptive pattern that gives life to the script but that does not dwell on insignificant information. The visuals should relate directly to the text and instructions beneath. The time of the average television advertisement can be between 30 seconds and one minute, so the number of visual stages needs to link exactly to the time specified by the budgeted slot. The visualization process may extend beyond the storyboards to a further stage in which the drawings are filmed and animated in a simple form that can be played back to the client with dubbed-in sound to give a rough moving picture of the proposed commercial.

The making of television commercials is an extremely expensive area of work. Good visualizers, capable of good figurative work, are highly prized, as it is important to sell the concept to the client at the earliest possible point in the production process.

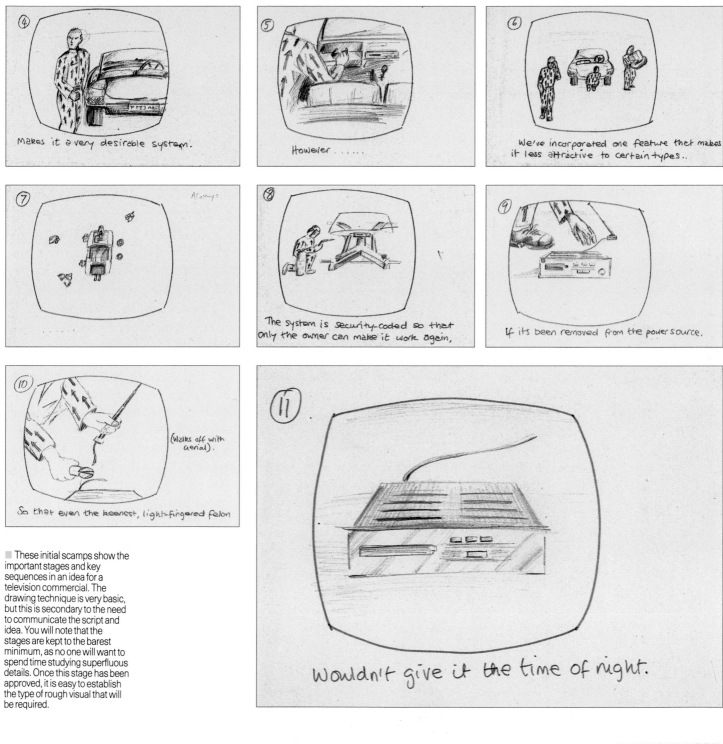

④ Makes it a very desirable system.

⑤ However......

⑥ We've incorporated one feature that makes it less attractive to certain types..

⑦

⑧ The system is security-coded so that only the owner can make it work again,

⑨ If it's been removed from the power source.

⑩ (Walks off with aerial). So that even the keenest, light-fingered felon

⑪ Wouldn't give it the time of night.

■ These initial scamps show the important stages and key sequences in an idea for a television commercial. The drawing technique is very basic, but this is secondary to the need to communicate the script and idea. You will note that the stages are kept to the barest minimum, as no one will want to spend time studying superfluous details. Once this stage has been approved, it is easy to establish the type of rough visual that will be required.

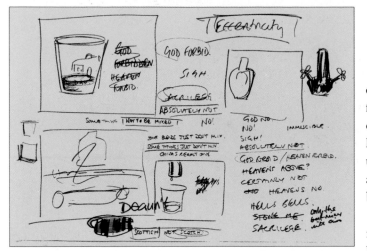

The press and magazines

Most press advertising is produced in black and white. This means that the qualities of line, tone and tints will be of great importance in the visuals you produce. It is worth remembering that many of the techniques that are applied to photographs are produced mechanically and can be specified at the time of artwork. You will be experimenting with a full range of black and grey markers to create compositional balances with the elements that are to be included. Advertisements rely heavily on specific visual images, and these are achieved with well-chosen typefaces, the imaginative use of photography and illustration and, wherever possible, the luxury of white space. The use of white space in advertisements is often frowned on by clients as the cost of each square millimetre can be expensive beyond belief!

Magazine and trade press advertising often offers a refreshing opportunity to include colour in your work. Newspapers too seem to be moving into the publication of colour pages, but there are some complications with the colour technology available for newspaper production, and you should be careful about the way you use colour here. However, the quality of most magazine printing is usually reliable, and you will be able to use colour and photographs without fear that the images will be distorted.

The important consideration in the creation of a rough visual for any advertisement is that it will be competing for attention with many other advertisements once it appears in print.

Once you have established a visual that has the approval of your client, you will need to produce versions of it in various sizes that can be used as a guide for the artworker. As space is purchased in the form of blocks on the page of the chosen publications, your advertisement will probably have to be a different size for each different publication in which it is to appear. These visuals are known as adapts, and their important feature is that the style of the advertisement is retained whatever size it is produced.

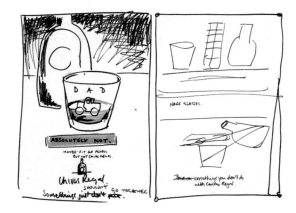

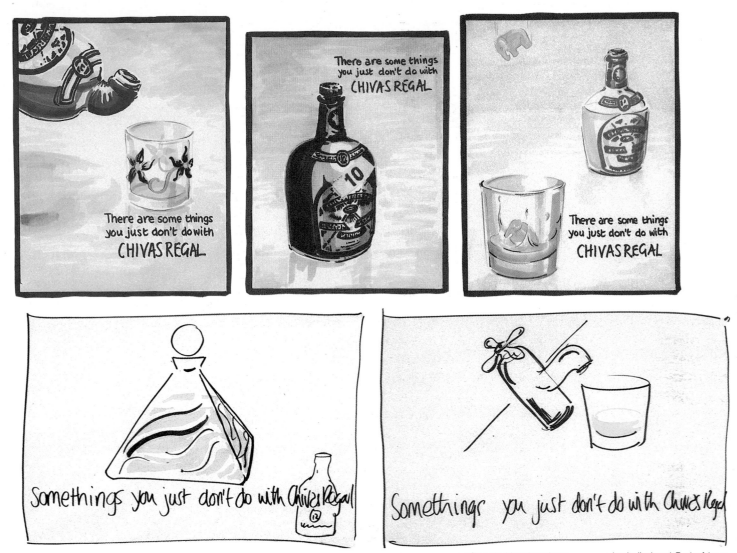

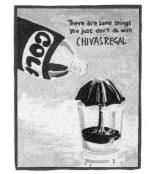

The ideas shown on the opposite page start as simple scribbles. These will evolve to form the shape and proportions of the advertisement. As they are merely emerging ideas, details and good drawing are unnecessary. Rather they should be produced in seconds if possible, new formats or ideas being quickly shown.

Once the ideas have been established, slightly more attention can be given to the visual quality. Of course when an advertisement relies on a visual concept, that concept must be clearly displayed. Each of these visuals would have been produced in five or ten minutes. It is important to consider the format, as this may change the emphasis of the concept.

Packaging visuals

CHECKLIST

- ■ Establish the shape of your container in 2-D form.
- ■ Draw up many alternatives.
- ■ Seek advice on the practicality of your chosen shape.
- ■ Decide if the graphics are to be applied direct or in the form of a label.
- ■ If direct, draw up the container shape as your design area.
- ■ Work the elements into the shape of the container.
- ■ If a label is to be used, draw up some alternative shapes.
- ■ Check these shapes against the container.
- ■ Work the design elements into the chosen shape.

Making rough visuals in this broad and varied area of design requires many different approaches and techniques. The starting point, as with any piece of design, is an understanding of the brief and its requirements. Next comes the design concept, which may cover many facets of the design and could be governed by cost and practicality. The first visual consideration is the size and volume of the product to be packaged. The product itself may need to carry part of the design; alternatively, in the case of a cosmetic container, the entire surface design would need your attention.

Let us make some hasty assumptions about the product for which you will be visualizing the package, starting with the product container, which, we will assume, holds a liquid substance. It is quite possible that the shape of the container will be part of the design brief.

Two-dimensional visuals

Initially you will experiment with the shape of the container. In the early stages there will be no need to adhere to practical manufacturing processes, and you should draw up a range of shapes as two-dimensional outlines in scamp form. As these evolve, the most suitable will be chosen and others discarded. You can now begin to pay more attention to the practical side of production, and at this stage you may need to seek the advice of an appropriate manufacturer. Once you have developed your ideas for the shape, you can experiment with the surface graphics. We will work on the assumption that the options open to you are direct printing on the surface of the product container or on labels that will be attached to the container.

If the graphics are to be applied to the shape directly, you should consider the elements and colours that can be explored. These will be drawn up within the two-dimensional representations of the container shape that you will have prepared on your layout pad. The shape of the container must be viewed as the design area, and your composition must work within this shape.

Alternatively, if the surface graphics are to be applied in the form of a label, you must first design the label shape to take account of the overall shape of the container itself. Once you are satisfied with the label, the graphics can be formulated within it.

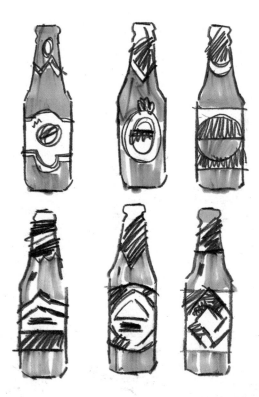

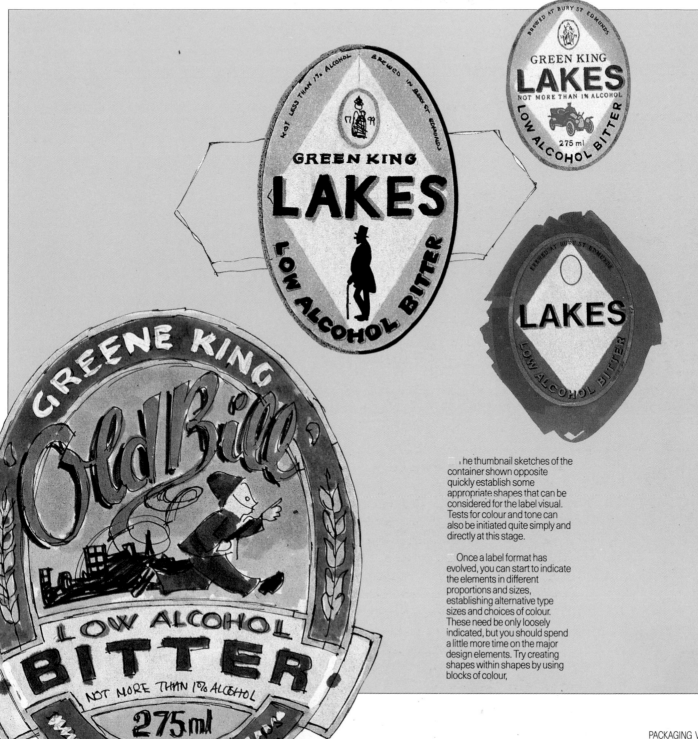

The thumbnail sketches of the container shown opposite quickly establish some appropriate shapes that can be considered for the label visual. Tests for colour and tone can also be initiated quite simply and directly at this stage.

Once a label format has evolved, you can start to indicate the elements in different proportions and sizes, establishing alternative type sizes and choices of colour. These need be only loosely indicated, but you should spend a little more time on the major design elements. Try creating shapes within shapes by using blocks of colour,

Visualizing the products together in a single drawing enables you to establish a coordinated and balanced design and colour scheme. You can quickly bring the design to life with a free but precise technique.

Three-dimensional visuals

When the design has been established as a two-dimensional drawing, you will need to develop your ideas into a three-dimensional format. If you are working on the container itself, you should experiment with its actual proportions and dimensions. These drawings, produced in markers or soft pencils, give life to the forms you have imagined, and they will appear on a sheet like finely moulded constructions. Clearly, it would be an advantage to view the container from different angles, and your drawing skills will need to be highly developed if this is to be successful.

If you are working on the surface graphics, you will need to overlay a sheet of layout paper and experiment with the graphic elements, bearing in mind the distortions that will occur now you are working on a three-dimensional shape. Once these elements appear visually correct, trace them onto your three-dimensional shape and colour them in.

The same distortions must be taken into account when you work on a separate label, but the advantage is that the graphics can be produced separately and later mounted onto your shape.

Colour and the skilful mixing of colour with the graphic elements should now begin to be apparent in your work.

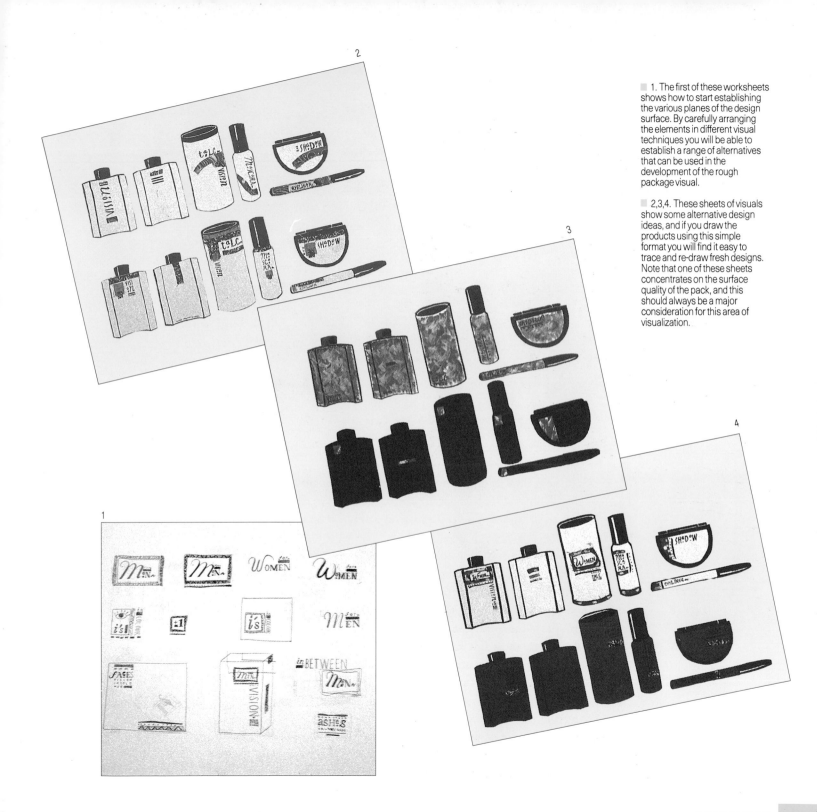

1. The first of these worksheets shows how to start establishing the various planes of the design surface. By carefully arranging the elements in different visual techniques you will be able to establish a range of alternatives that can be used in the development of the rough package visual.

2,3,4. These sheets of visuals show some alternative design ideas, and if you draw the products using this simple format you will find it easy to trace and re-draw fresh designs. Note that one of these sheets concentrates on the surface quality of the pack, and this should always be a major consideration for this area of visualization.

CHECKLIST

■ Look at the structure of a number of packs.

■ Dismantle several packs to understand them as flat graphics.

■ Consider the product and the pack together.

■ Explore the concept by developing alternatives of the theme.

■ Exploit visually the divisions of your pack.

■ Draw up a number of the same shapes on your pad showing two sides and a top.

■ Work up the design.

■ Know the competition.

■ Tip: reverse the elements of one of your designs for dramatic contrast.

Outer packaging

You should have a basic knowledge of the ways the outer cartons or product containers are engineered as this will help you to understand the variety of shapes that can be made with the materials available. The best way to initiate this research is to study packaging that has already been produced. Dismantling the packaging will enable you to see how the graphics are applied and also give you a basic knowledge of the construction.

The contents of your container may form part of the design brief; alternatively, you may be involved in the outer design only. If both elements are under your control, you have a unique opportunity to coordinate these two items and to use all manner of interacting design ideas. Experiment with developing the inner product and the outer pack both individually and together.

Once you have created the concept, the rough visuals that follow should explore the alternatives available within this set theme. One way of developing your scope for creating alternatives is to take an existing image and, using the same elements and colours, to reverse them from light to dark. This will instantly change the design without necessarily changing the concept.

The advantage of standard packs is that the sides divide the areas proportionately. You should exploit these divisions visually to give contrast to the three dimensions. Draw up a number of shapes on your pad showing two sides and a top and work out the surfaces as individual design areas and as a part of the whole.

Finally, always research the competition, as your pack will occupy the same selling area, and you will, of course, want your design to attract the most attention.

■ The golf package has been visualized using markers, and, to give shape and form to the package, the greens have been varied. This effect can be achieved simply by using lighter and darker markers or by overlaying a single marker to achieve a darker colour. The contents of the pack are visible through the top of the package, covered with a plastic sheet. Again, this is simply described with white highlights flicked across the contents.

■ This confectionery packaging displays many different design elements. These are linked through the style of visualization and united with the loose drawing of the base around the products. By quickly scamping in a base you give dimension and form while uniting the products in a lively, expressive manner.

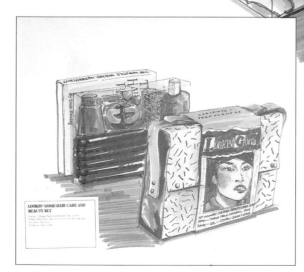

■ It is sometimes necessary to link the graphic elements to an already created product. In this hair care rough, the wrap-around graphics have been styled to accommodate the established products. This has been simply achieved with careful coordination of colours.

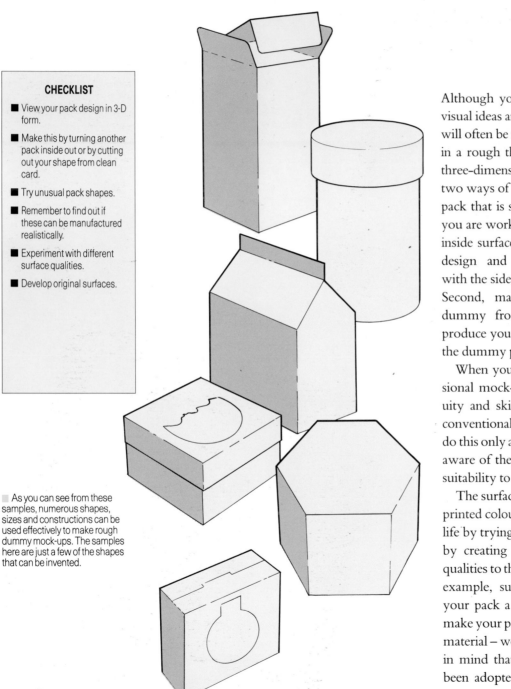

As you can see from these samples, numerous shapes, sizes and constructions can be used effectively to make rough dummy mock-ups. The samples here are just a few of the shapes that can be invented.

The dummy pack

Although your concern is with the production of visual ideas and alternative versions of these ideas, it will often be necessary to view the design or designs in a rough three-dimensional form instead of as a three-dimensional drawn interpretation. There are two ways of approaching this. First take an existing pack that is similar to the shape and size on which you are working and dismantle it carefully. Use the inside surfaces that are free of print to attach your design and piece it back together, this time with the sides carrying your designs on the outside. Second, make up a rough but fairly accurate dummy from card of the appropriate weight, produce your designs separately and attach them to the dummy pack.

When you are experimenting with three-dimensional mock-ups, it is possible, with some ingenuity and skill, to devise some alternatives to the conventionally shaped pack. It is really possible to do this only at the dummy stage, as you will become aware of the potential of the materials and of their suitability to the manufacturing process.

The surface of your pack will not always be a flat printed colour or tone. You may bring your pack to life by trying out textured papers and surfaces, and, by creating your own alternatives, you can add qualities to the structural appearance of the pack. For example, surface that imitates concrete will give your pack a hard and heavy appearance. You can make your pack look as if it is made from almost any material – wood, leather, fabric and so on – but bear in mind that many of these surfaces have already been adopted for certain styles of design, so you should try to invent your own surface appearance.

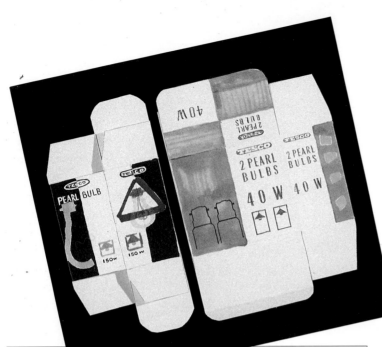

It is important to establish a flat plan of the dummy pack. This can be produced by using the proportions of a dismantled pack but adjusting the size to accommodate your ideas. The flat plan shown here is the construction of the carton at the top of the facing page.

A Front
B Right side
C Back
D Left side
E Bottom tuck flap
F Top tuck flap
G Bottom flaps
H Top flaps
J Glue seam

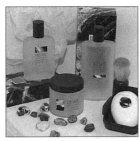

This range of packages and products was created by utilizing available glass containers. The tops were sprayed with aerosol. The packaging was produced to accommodate the products, and the visual was made up for the cartons using photocopies of a visualized surface texture.

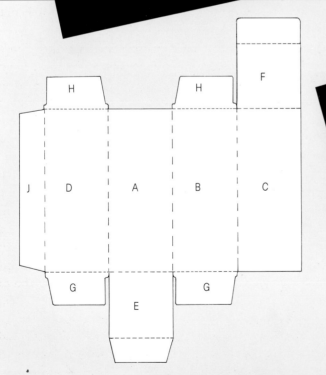

The light bulb packaging shows the visual flattened so that you can see the design coordinated on the surfaces.

General design visualization

CHECKLIST

- Understand the pre-determined style for the book.
- Produce some thumbnail shapes showing the underlying grids.
- Draw up alternative thumbnails of the design elements.
- Consult with the photographer or illustrator.
- Translate the thumbnail sketches into full-size spreads.
- Render in the headings and sub-headings.
- Indicate photographs and illustrations.
- Show body type with lines or by "n-ing".

General design visualization can be divided into a number of areas. The following pages give examples from professional designers and visualizers.

Books

Publishing has become a major design area. Modern books, especially non-fiction, instructional books, often carry a great deal of graphic and visual information and require both photography and illustration to embellish and assist the text. Some books have a fairly equal balance of text and illustrations, although there is a vast children's market in which innovations such as cut-outs and pop-ups dominate the text.

Often there will be some definite, pre-set guidelines. For instance, if a publisher produces a family or series of books, a grid governing the style of the pages is likely to have already been established. The task of the visualizer will be to draw up the elements for each of the pages into compatible compositions within the existing grid.

The visuals for children's books can make or break the interest that will be generated in the readers, and this work is often produced by an illustrator who will be appointed by the art editor. Similarly, book jacket design is also the province of the illustrator, although an in-house designer may control the layout of type and specialist information.

The first stage in the design of the page spreads would normally be the production of thumbnail sketches showing the grid and the elements in position; the next stage is a full-size rough. The design for the book jacket may be sketched out to give a feel for the type of illustration and style, and this would be followed by a further rough, produced by the visualizer in collaboration with the illustrator. Your visual for the book concept will be used either to demonstrate to the publisher how the design works or as a guide to the finished artwork. There is a lot of interesting visual work in this area of graphics, although it does require some specialist knowledge of book production techniques.

■ This fairly accurate rough visual has been produced to convey all the graphic elements in a precise and clear manner. This book jacket was produced to this exact standard as the client was able to appreciate the visual only as a finished product. The background colour is applied in marker, lettering is painted in white gouache, and coloured illustrations are attached separately.

1. The first of these page spreads shows the drawing of the title page. This has been rendered accurately, although there is only a hint of the actual typefaces.

2. This contents spread shows how different degrees of line thickness can be used simply to express typographic image.

3. The example shown here of the page layout combines type and illustrations, where the latter have been indicated in outline to give an overall design and position guide for all the graphic elements.

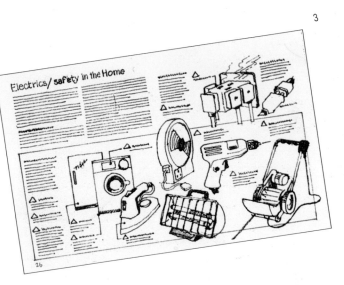

These book jacket visuals have been generated by a computer graphic process. The graphic elements can be fed into the computer and displayed on a monitor on which visualization of alternative designs can be produced.

This book jacket has been produced on a graphics computer, and two of the stages of the visual process can be identified in the illustrations above.

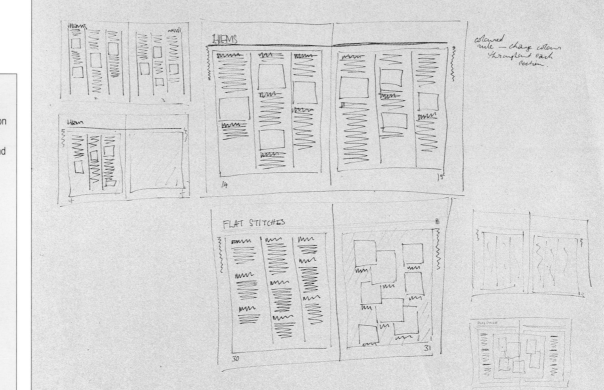

■ The illustration at the top of this page shows a typical initial worksheet of a magazine spread. These alternative layouts show how the elements – the typography and pictures – can be quickly arranged to create different visual effects. Although these drawings are very loose, you will note that they adhere closely to an established grid formation.

■ Once the elements have been arranged it may be necessary to show the type and pictorial matter in a little more detail. You will note that these are still produced in a single colour, as colour is not necessary to determine the overall layout.

Magazines

This highly competitive market offers vast opportunities for creative visual input, while the initial styling of any new publication is especially exciting. The first and major role is to establish the image for the magazine with a concept that is targeted at a specific readership. The editorial approach is certain to be instrumental in dictating the style and image, and the designer/visualizer will need to pay special attention to these ideas. In addition, marketing experts will be adding their voice to the concept to promote sales.

In the initial stages a great deal of careful attention is given to the typeface styles, the number of columns of type to a page and the space that the

printed matter will occupy. Many visual versions of these elements may be required before a final decision is made, because these details are crucial to the final typefaces and grids, which, once set, will be repeated time and time again. In brief, the idea is to set a style that you can follow for a very long time.

Once the magazine is up and running and its readership has had the opportunity to offer feedback, the publication can be fine-tuned visually to meet their requirements. There is, however, an ongoing need for visuals to be produced. Every publication has its own approach to this. Some may need only scamp visuals for the production team to follow, while more often than not there is an in-house editorial or management need to see the rough layouts of pages before they reach the production stage. How detailed these are will depend on the personnel concerned.

When colour is used in magazine publishing, it is preferable if the colour used in the editorial design is kept distinctive and low-key, as the advertising and your own colour illustrations and photography will be sufficiently strong without introducing additional competition on these pages.

■ This precise layout and visual have been produced to describe all the visual elements as closely as possible to the finished appearance, while still retaining a loose and slick appearance. It is not necessary to render text in such a precise manner, although it is a useful exercise.

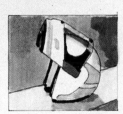

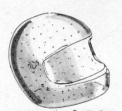

Newspapers

A great deal of excitement and energy go into the creation of newspaper spreads, and into the arrangement of headings and type and the balance they achieve with the photographic images. Each newspaper communicates its own visual style, and the layout artist must be finely tuned into the editorial ethos of the paper, carefully following a pattern of visual standards that have been developed over many years.

The more popular nationals often pander to their readers with a style that relies on punchy headlines and stunning photography. It is the visualizer's job to bring together the two major components – photography and text – and to give the correct balance and prominence to each feature on display. The visuals are produced as the text and photographs become available, and they are used as the basis for discussion and approval by the editorial management. The visuals are then used as a guide to page make-up, although modern technology in newspapers allows journalists to prepare simple page settings, but still under the guidance of a skilled visual professional. The speed with which newspapers are put together demands an ability to make instant visual interpretations. The typefaces and column designs are pre-determined, so it takes little time to develop a set of standard parameters, but the master skill is an ability to combine the elements in such a way that there appears to be a fresh approach to each spread.

The "heavier", more intellectual newpapers are also conscious of their presentation, and they spend a great deal of money and effort on making use of new techniques and expert design input to update and polish their image.

The visualizer would normally work in grey tints and line images, although spot colour – ie, a single, second colour – and even full colour have now come into the national newspaper market. The essence of professional visualization in this area is the speedy development of layouts, created to a full-size format, that can be used for in-house consultation and production work.

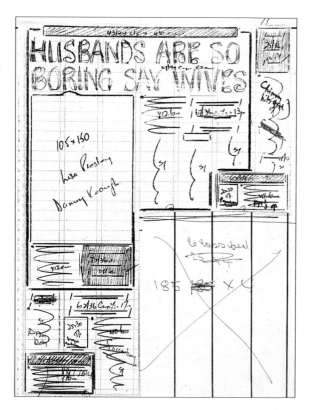

■ The major concern of the visualizer here is to produce a clear layout and to place sufficient emphasis on the lead article.

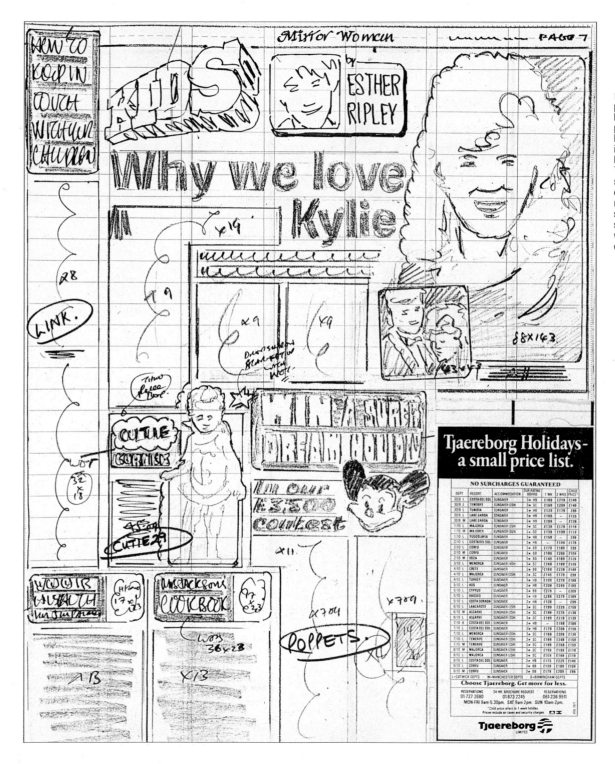

This page, which has been produced in more detail, shows a busy use of layout design that is punctuated by reversed-out headings. Pictures are broken into pictures, and illustrations break out of boxed rules.

The intention behind this spread is to create a busy and exciting layout that will give the reader a host of interesting snippets. The drawing technique is simple and precise yet produced with speed and the minimum of effort.

The layout above, which was produced for a gatefold brochure, carefully plots out all the visual elements. The illustrations are loosely indicated using fine liners and coloured pencils. Where pictures have been available, appropriately sized photocopies have been positioned on to the layout.

Visual ideas can be made to look striking. This visual has been rendered in markers with the matches highlighted in gouache. By carefully tracing off established company detail, such as the name and logo, and rendering it accurately, the client will quickly link your visual with his company style.

Leaflets, brochures and newsletters

A great deal of work is involved in designing publications ranging from the single-sheet leaflet, to the in-house newsletter up to the company brochure.

This vast range opens up an array of visualization applications, media and skills. The leaflet, which is often used for a specific campaign, can be quickly visualized using the skilled marker techniques you have developed. A leaflet would normally, after the production of some initial thumbnail sketches, be visualized to the actual finished size, and the visual produced would quickly rationalize the design elements to a direct formula.

The newsletter requires a more cautious approach. You will have to describe the delicate balance between type sizes, which could vary from column to column, and also pay attention to column dividing rules and other separating design devices and to whatever styling details are necessary. For instance, if vertical dividing rules are used as column separators, these should be drawn at the correct thickness even at the early stages of the layout. Such considerations also apply to newspapers.

Your visual should be carefully drawn and rendered using a precise size of marker nib for the rendering process. Be very selective in choosing the right pen for the mark you wish to make.

Photocopying the various elements and some skilful paste-up can take the drudgery out of making these visuals.

At the other end of the scale is the company brochure, which can have just a few pages and be produced in a single colour or which can be a lavish, multi-coloured, many-paged sales or promotional communication tool. Depending on the budget allocated to the job, you will be involved either in the quick marker impression produced on layout paper or in the preparation of a more carefully drawn and finely detailed visual, when all manner of media will be included to create the desired effect. The standard you wish to achieve in your visual will, therefore, be determined by the budget.

Finally, whatever the brochure size, remember that you should produce only as many sample pages as are necessary to describe the concept fully and to convey the flavour accurately.

■ Different jobs attract different approaches. These page roughs for a business brochure have been sensitively created with the lightest flick of a fine marker.

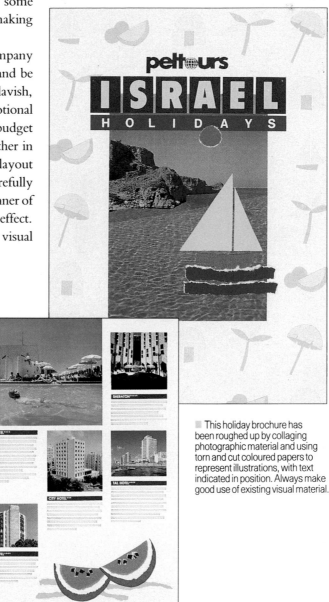

■ This holiday brochure has been roughed up by collaging photographic material and using torn and cut coloured papers to represent illustrations, with text indicated in position. Always make good use of existing visual material.

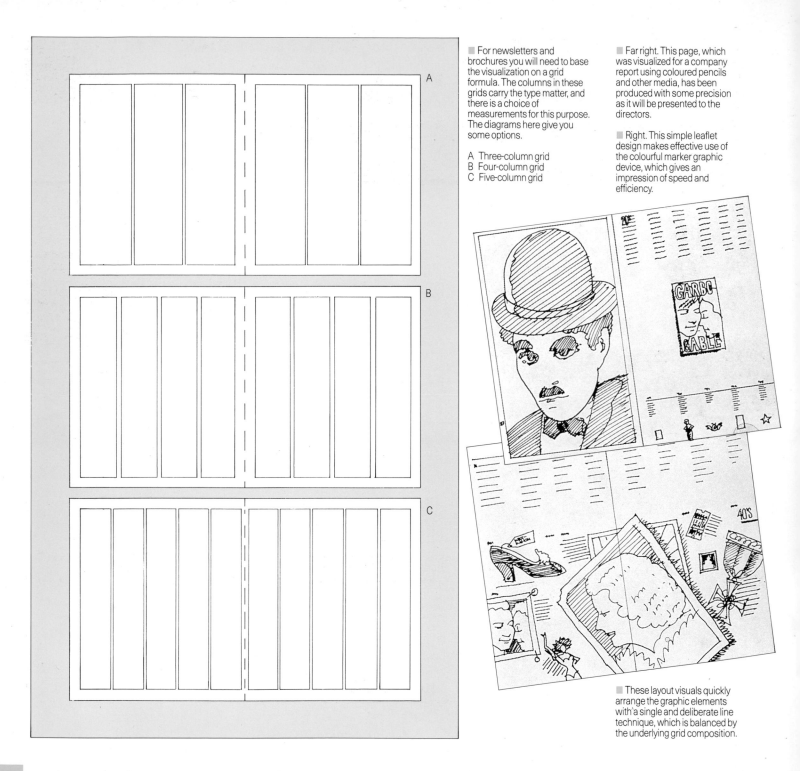

■ For newsletters and brochures you will need to base the visualization on a grid formula. The columns in these grids carry the type matter, and there is a choice of measurements for this purpose. The diagrams here give you some options.

A Three-column grid
B Four-column grid
C Five-column grid

■ Far right. This page, which was visualized for a company report using coloured pencils and other media, has been produced with some precision as it will be presented to the directors.

■ Right. This simple leaflet design makes effective use of the colourful marker graphic device, which gives an impression of speed and efficiency.

■ These layout visuals quickly arrange the graphic elements with a single and deliberate line technique, which is balanced by the underlying grid composition.

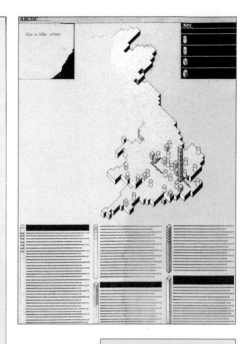

CHECKLIST

- Make thumbnail sketches of the concept.
- Produce quick, full-size visuals for a simple leaflet.
- Use precise visualizing instruments for newsletters and typographic work.
- Use photocopies to cut down the workload.
- Pay special attention to the finer design details.
- Prepare more finished detail and include the use of many media in brochure work.
- Tip: sample pages are all that is required.

CHECKLIST

- ■ Work out alternative concepts.
- ■ Work these up to rough visuals, using many techniques.
- ■ Consult with your client.
- ■ Re-visualize on the strength of your client's preferences.
- ■ Re-submit new visuals to a pre-determined standard.
- ■ Agree on the logo of your client's choice.
- ■ Remember that the client may wish to see several alternative sizes and techniques for the chosen idea.

HORTIMAN

HO

Corporate images (logos)

Designing a logo is possibly the most important, and certainly the most costly, area of graphic design. The concept created for a company logo is rigorously and relentlessly pursued, and the designer has to explore every facet of the company operation, building up a picture that can be condensed into a single means of communication. This work is so important to client companies because they usually expect the image to be at the forefront of their business activities, and the logo will be applied to every piece of company information, from letterheads to advertisements to livery. Company images must describe the finest qualities of the business, and the directors will be looking for appropriate and stylish logos of which they can be proud.

To initiate this work more than one design concept will normally be produced, and these alternative concepts will require the full visualization treatment. In the early stages they will be produced as loose but accurate visuals, and they may even be presented at an early client meeting. The decisions reached and ideas discussed at this point will help to

model the concept, which is then taken further. Again, alternative visuals of this emerging idea will be freely developed using a variety of design tricks and techniques. For instance, if your image is in black on white or in a colour on white, reverse this and the image will instantly change. Similarly, varying the proportions of the design will change the emphasis. Colours will give the elements characteristics that can be explored visually to change the temperature or mood.

The level at which you pitch your rough visual will be determined by the size of budget and the specified requirements of the client. Remember, I have not so far discussed the logo as anything other than an isolated, unattached image, but once your rough visual has been approved, its application to the company's actual needs must be considered.

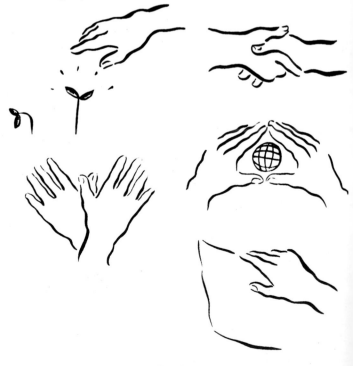

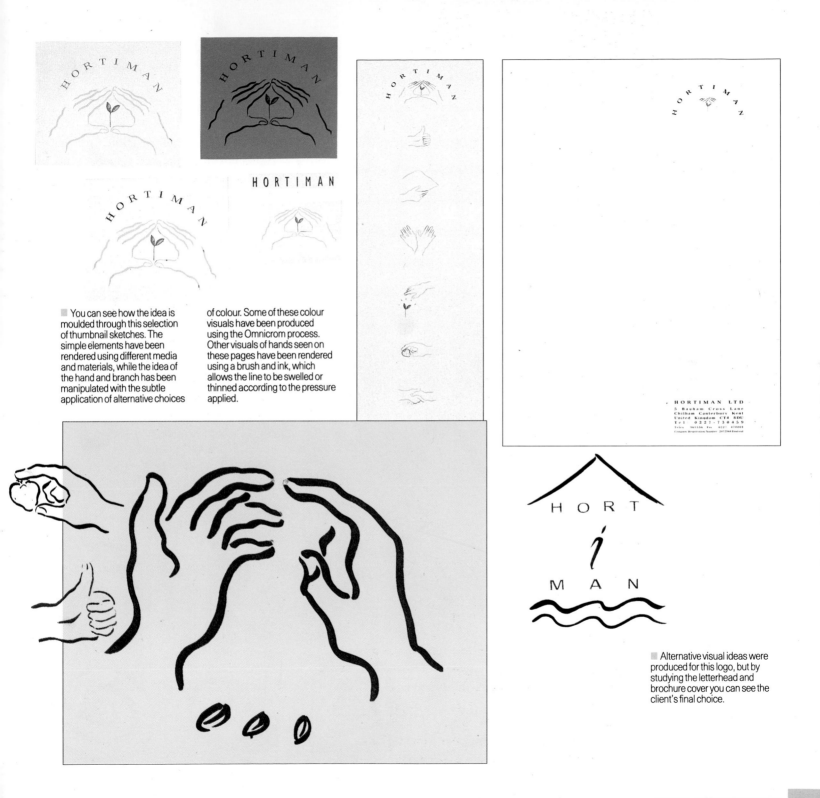

You can see how the idea is moulded through this selection of thumbnail sketches. The simple elements have been rendered using different media and materials, while the idea of the hand and branch has been manipulated with the subtle application of alternative choices of colour. Some of these colour visuals have been produced using the Omnicrom process. Other visuals of hands seen on these pages have been rendered using a brush and ink, which allows the line to be swelled or thinned according to the pressure applied.

Alternative visual ideas were produced for this logo, but by studying the letterhead and brochure cover you can see the client's final choice.

HORTIMAN LTD
5 Bagham Cross Lane
Chilham Canterbury Kent
United Kingdom CT4 8DU
Tel 0227-730459

A number of alternative symbols and images will be initiated through the design process for a logo to be applied to the stationery and livery. These visuals will be used as the basis for the presentation.

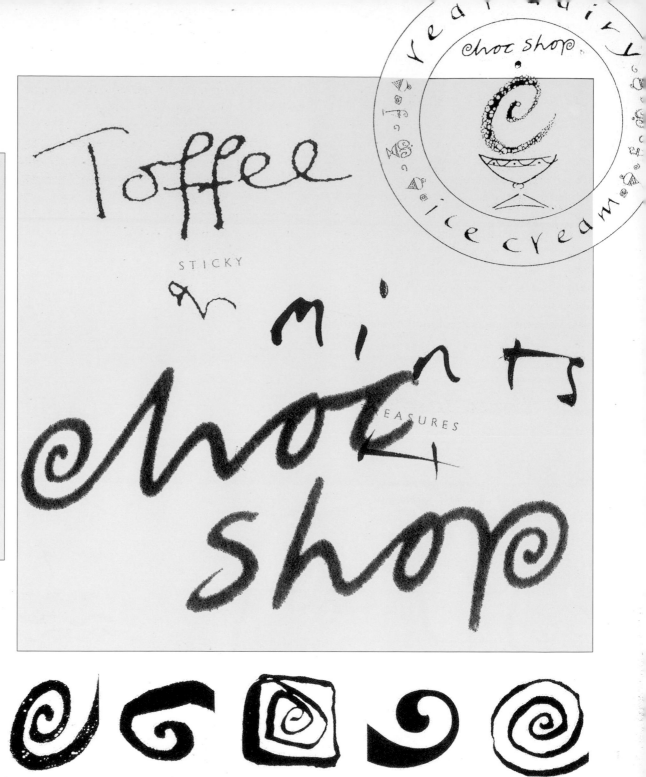

Corporate images (stationery and livery)

Once the logo image has been finalized, the image is applied to all the company's printed and promotional material. The first requirement will be for the image to be used on the stationery, and the subtleties involved in the design process to apply the logo will once again demand special attention. The logo is only one part of the overall effect, for the styling of the stationery itself will give rise to an image. The choice of typeface and the size and proportion of this type together with the effective use of space will need to be explored. You will again have to produce alternative layouts for your client.

The other main use for your logo will be its application to the company's external image, especially on vans and lorries, on signs and even on film, television or video. When applying the logo to the company's livery, it is advisable to obtain some elevation drawings of the vehicles that are used. These can easily be photocopied and used for the initial scamp designs. The complexity of the design and its elements will tell you how much further your designs need to be developed.

■ A range of stationery visuals can be produced, either rendered in black and white as the actual colour to be used, or made into colour visuals using the Omnicrom process. The proportions of the logo and its size in relation to the type should be equal throughout each piece of stationery.

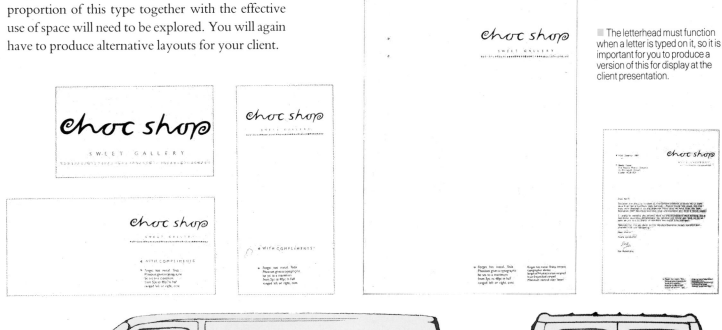

■ The letterhead must function when a letter is typed on it, so it is important for you to produce a version of this for display at the client presentation.

Visualizing illustrations

Nearly every piece of design work will have some element that requires illustration. Some simpler work will be finalized by the finished artist in the final production. For instance, simple stylized elevation drawings can easily be interpreted as line artworks, and the colours that are included in these drawings can be marked up before printing. Some work can be kept to a basic level that enables you to indicate in your rough visuals how it should be translated in the usual artwork process. If the illustrations you are indicating involve more complex techniques – scraperboard, woodcuts, linocuts and any variety of specialist techniques, for example – you will need to have an illustrator in mind when you create the rough visual. I am stressing this aspect of the process and the care that you must take because at some point your visual must be translated into finished graphics.

The first point you must consider is the complexity of the illustration; next, you should think about the image that is going to be conveyed. If the style of illustration is influenced by a particular professional, you should find out whether your budget can afford his or her services and, of course, if he or she is available to work on the project.

Another factor to bear in mind when you are imitating an illustrative style is that you may well need to use the actual style and technique used by the preferred illustrator when you are rendering your rough visual. If your illustrator works with a particular pen or brush technique, it is clear that a marker pen may not be adequate for the job. A note of caution, though: if you wander from any particular style in your enthusiasm for image, you could easily be left in the awkward situation of not being able to find a willing translator of the style you have created.

Always keep on file as many visual examples of up-to-date work as you can find. You should use these both as drawing references and as references for the particular styles employed. I have scrapbooks showing heads, hands and the body in various positions. In addition, other collections include practically every other form of illustrative subject matter. Even photographs can be used as a basis for your initial scamped interpretations.

■ The designer produced this illustration idea from torn coloured paper, an excellent way of making a colourful, simple image. By carefully tearing and sticking, you can make exquisite visuals.

■ The fashion drawings seen on this page are typical of the stylized images that can be found in many publications. By utilizing these forms, you can adapt costumes to suit your own design requirements.

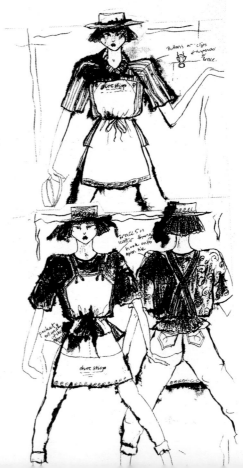

■ You can see how this finished image has evolved through a series of sketches produced by the designer. These are the basis of a good design brief for the illustrator to work from.

■ The idea for the illustration of these two people has gradually evolved through the worksheet process. Making and developing scamps for illustrations is no different from designing and creating other graphic images – you must develop the idea through a sheet of scamps.

■ This line drawing, although stylized, is typical of a technique in common use. Different marker thicknesses allow you to create many subtle images by controlling a whole range of line marks. This sort of drawing is highly desirable and is sought after for many projects.

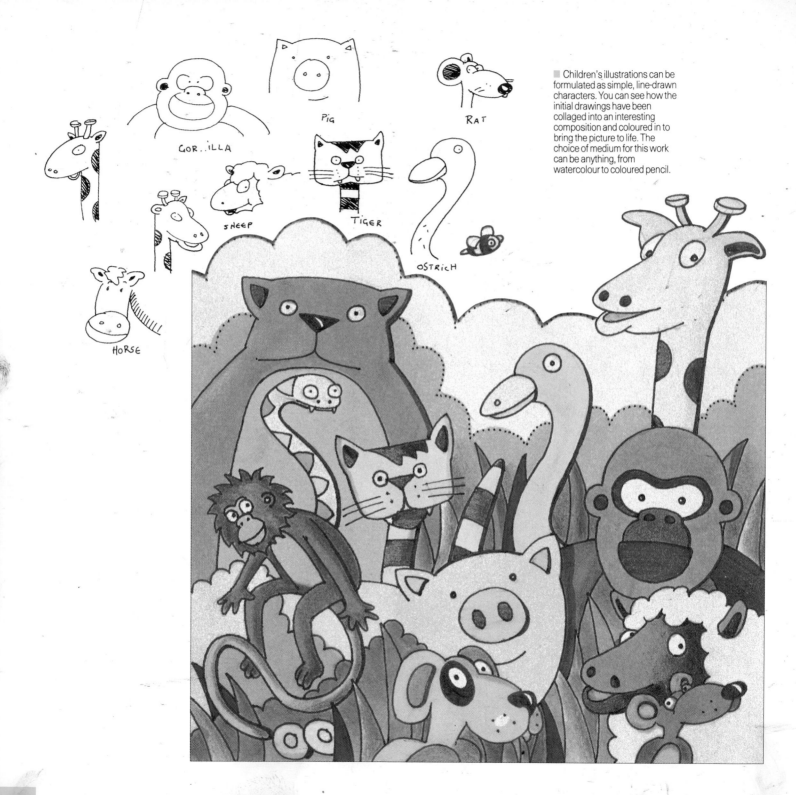

GOR..ILLA

PIG

RAT

SHEEP

TIGER

OSTRICH

HORSE

Children's illustrations can be formulated as simple, line-drawn characters. You can see how the initial drawings have been collaged into an interesting composition and coloured in to bring the picture to life. The choice of medium for this work can be anything, from watercolour to coloured pencil.

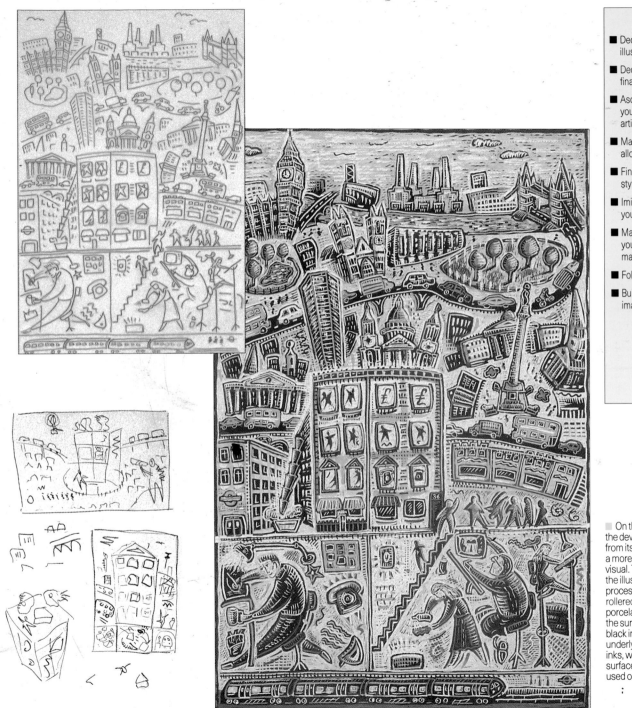

■ On this page you can follow the development of the illustration from its initial scamp, through to a more careful drawing, to a final visual. The technique used for the illustration is scraperboard, a process in which black ink is rollered over a chalk- or porcelain-finished board. When the surface is scratched and the black ink removed, the underlying white is revealed, and inks, which are absorbed into the surface of the board, can be used on the final drawing.

PROFESSIONAL VISUALIZATION

THIS FINAL SECTION of the book is devoted solely to the comparisons that can be made between rough visuals and the finished pieces of work. Every design company's concern, when it is presenting a concept to its clients, is how to bridge the obvious but intangible gap between what is, on the one hand, the personal interpretation of one professional individual and what is, on the other, a vastly sophisticated, technically precise, manufactured piece of work.

The key to knowing where to start is to have a clear understanding of the client with whom you are working. His or her individual perceptive abilities need to be assessed and measured. If the client has had some training in design, it will be likely that he or she will understand the early visual interpretations of the concept you have been commissioned to work on. This luxury, although it is quite rare, is a delight to encounter. I call it a luxury because the freedom you have in preparing your visuals can relieve the visualizer of arduous, lengthy and technical application.

In view of the expense that can be incurred in the modern design industry, it is becoming established practice for companies to familiarize themselves with the techniques used by visualizers. If a client has little visual sense, expensive and time-consuming processes can involve the designer/visualizer in a frustrating breakdown of communications, made worse by the knowledge that each step in the design process is incurring increasing expenses which can snowball out of all proportion to the initial, agreed budget. More importantly from your point of view, the visualizer may be involved in further work, which was both unforeseen and unnecessary. I speak from personal experience. One client requested a sales broadsheet produced in single colour; the visual was approved, the artwork completed and the printed proofs supplied before the client decided to indicate the changes he required. So unaware was he of the expensive sequence of events that he was quite alarmed when the full financial implications were revealed. At this point he admitted that he was unable to visualize rough illustrations and could only assess the printed image itself. Once this was established, I was able to tailor the visual to his specific needs.

Now that you have read of just some of the problems you may encounter in your dealings with your clients, this section of the book shows how some of the best designers realize their visual ideas and how these link visually to the printed work.

There will, of course, be discrepancies between what is shown as a visual and what appears as the printed or published work. First, you will see the idea or concept evolving. Naturally, many dis-

cussions will have taken place during the processes that take place between the first showing of the visuals and the appearance of their printed counterparts. However, you should be able to identify some common characteristics that will emerge from the visuals and that can be seen in the finished piece. Second, and more importantly to you, you should remember that although the visual and the printed piece may look quite different, if the rough has been rendered with confidence, it will encompass the spirit of the printed work and positively echo the professional way in which the whole process is being handled.

As I have already discussed, some clients may need the work to be developed through many stages. These stages are both recognized by, and are established within, the design industry. This book's concern is with generating the rough visuals, but, clearly, you may have to produce the ideas to intermediate or finished roughs or even to mechanical representations of the work.

Finally, I should mention that, even as this book is being written, design processes are evolving through technology into a new era. It will not be long before much of the visual work generated in the design industry is done with the aid of computers. It is already possible to explore the design elements and their component colours quickly and effectively on a computer monitor. The only restriction to this process is the facility to produce accurate, good-quality printouts. When these are not needed – in television, video and film – the computer has already found a home. However, as soon as high quality printers become more readily available, it is certain that much visualization work will be produced electronically. But you should never forget that, whatever visualization tools become available, the skill and artistry of the designer/visualizer are paramount and irreplaceable.

An example of the visual for this section of this book is shown here. You can see how the visual differs from, but is linked to, the final printed form.

Advertising

Rarely do you get an opportunity to walk into a professional studio, open the drawers of the studio plan chest and glance at the plans that preceded major national advertising campaigns. If you were so fortunate not only would you see the familiar pieces of graphics but you would also be able to envisage the struggles that took place during their evolutionary process.

On these pages you are privileged to be able to see just a few of the stages that have gone into the making of what we, the public, finally see as finished points of communication through the medium of advertising.

While studying the visuals and comparing them with their finished counterparts, pay special attention to the development of the graphic elements. You should be able to identify the point that is going to initiate the visual relationship with its final appearance. For example, when elements such as typography are indicated, the following questions must be posed. What will be understood in the initial stages and what will register with those concerned? How much work will be sufficient to describe those elements? How are the elements going to evolve? With advertising, the concept is paramount. The visual process is often regarded as rather secondary but if the concept communicates, the graphics are almost obvious and will emerge automatically. This is why most advertising concepts are initially described in very loose visual terms. This is possible because the concept itself, in its simplicity, describes the nature of the visual elements. If this does not work in the initial stages, it is likely that it will either require stunning visual treatment or it will fail completely. The visual that will emerge must only take account of how the concept is going to be displayed. If the concept is thought-provoking, the visuals will have to echo this statement. If characteristics or markets such as age groups or social distinctions are relevant, the briefing will specify them. The definition of emphasis or any subtle distinctions lies in the territory of the visualizer. The combination of all these elements makes the advertising industry a lively, interesting and creative place to work.

■ The first task of the visualizer is to interpret the idea in visual terms. You can see that the merest hint is sufficient to formalize the concept for this advertisement.

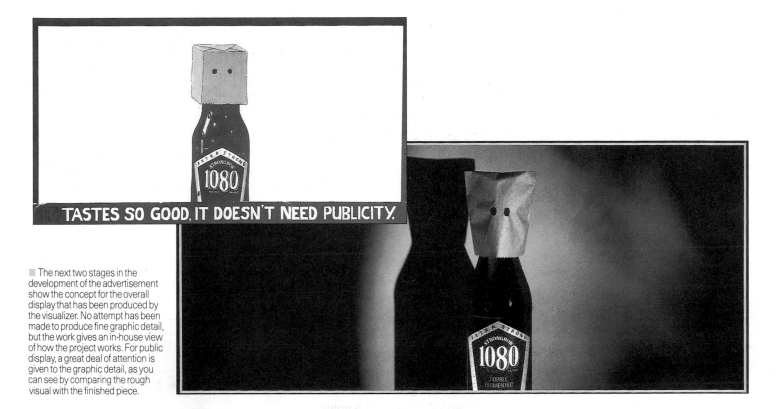

TASTES SO GOOD, IT DOESN'T NEED PUBLICITY.

The next two stages in the development of the advertisement show the concept for the overall display that has been produced by the visualizer. No attempt has been made to produce fine graphic detail, but the work gives an in-house view of how the project works. For public display, a great deal of attention is given to the graphic detail, as you can see by comparing the rough visual with the finished piece.

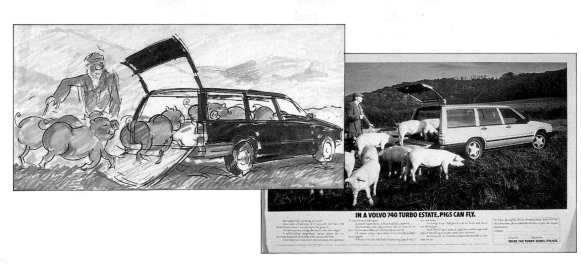

IN A VOLVO 740 TURBO ESTATE, PIGS CAN FLY.

By comparing this rough visual with the finished Volvo advertisement it is easy to see the changes that have taken place as the work has evolved. The advertisement has become more upmarket in concept although the initial idea and layout have suffered little change.

On the following pages I have selected a few key pieces of work. Viewing these will give you an opportunity to gain a brief insight into the work that passes through advertising agencies. You will also be able to see the type of visual that is required for a colour press advertisement. The drawing skills that you will need to exercise for the different visuals involved in the creation of each area of advertising are also clearly discernible from these examples. For instance, capturing the imagery for film work demands a higher level of illustrative skill in the visualization than is required for an everyday press advertisement.

Finally, the styles used for this work will provoke different responses. You will like some more than others. Whatever your preference, however, you should recognize the levels of professionalism involved and the degree of individuality achieved. If you wish to pursue a career in advertising visualizing, you must be professional in the use of the media and seek out the agencies that approve of your working methods.

This typical rough visual for an advertising project explores the layout concept and graphic elements with spontaneous images created in marker pen. The speed and accuracy give a fresh and lively feel to the concept. You can see how closely linked this visual remains to the finished piece.

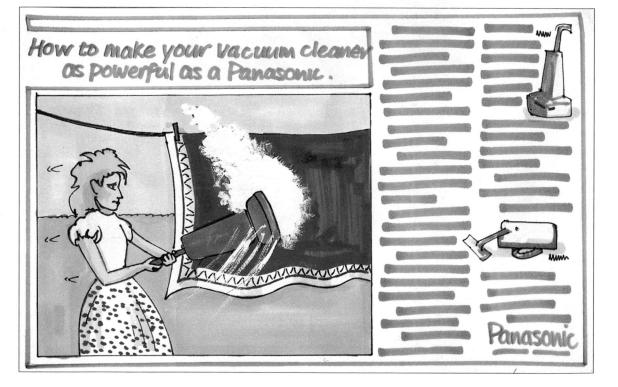

How to make your vacuum cleaner as powerful as a Panasonic.

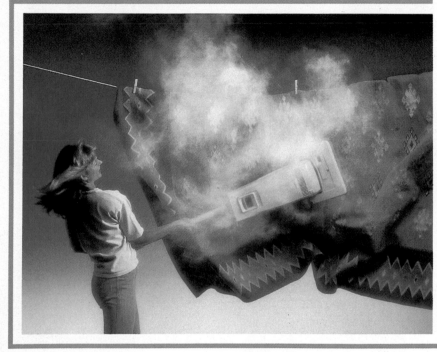

Most vacuum cleaners will remove the dust and dirt from your carpet.

But a powerful Panasonic will also suck out the grit hidden deep down in its pile.

Grit which would otherwise lie there, cutting into the fibres, and taking years off your carpet's life.

Consider, for instance, the Panasonic MCE92N cylinder model.

MCE92N

With a full 1200 watts of cleaning power, it works quite a bit harder than most vacuums.

In fact it's so powerful that we've put castors on its cleaning head to prevent it clinging to the carpet.

And we've given it a huge 6.1 litre reusable dustbag to cope with all the extra dirt you'll find.

Along with lower power settings, letting you clean curtains and upholstery easily.

And a three stage filter system to prevent dust blowing back into the room. (And on to your carpets and furniture again).

But if on the other hand you prefer an upright model, how about the elegant Panasonic MCE 43 Wall-to-Wall Cleaner?

Its side brushes loosen and lift dirt right up to the skirting.

And its powerful motor will leave your living room spotlessly clean.

It even has a headlight to seek out the sneaky layers of dust that lurk under furniture.

MCE43
Wall-to-Wall Cleaner

Then for those of you with smaller houses and flats there's the Panasonic MCE89.

It's compact and lightweight so you can carry and store it easily.

Its tools pack neatly away inside to save even more space.

And its dustbags are reusable too. (Which will save you a bit of money).

MCE89

Yet with 1000 watts of cleaning power, it's in the same class as the other Panasonic vacuum cleaners.

Unbeatable.

Panasonic
VACUUM CLEANERS

Please send me details of the Panasonic vacuum cleaner range.

Name ...

Address ...

To: Advertising Dept. Panasonic Consumer Electronics UK
300-318 Bath Road, Slough, Berks SL16JB. Tel: Slough 34522

■ Here you see the finished advertisement. The layout faithfully follows the initial rough, and even the photography, in terms of layout, has been carefully taken to create the same picture format. However, the styling of the photography has influenced the creation of the final image – the photographer was carefully chosen, and the setting and lighting were devised during the photographic session.

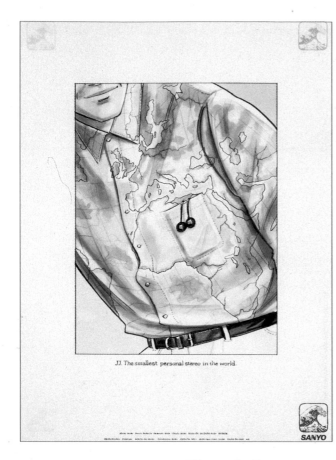

JJ. The smallest personal stereo in the world.

■ By comparing this
advertisement with its rough visual,
you can see how the concept of the
man's shirt representing the world,
which was produced initially as a
fairly tame and restrained visual,
has been finally developed into an
aggressively modern, slightly
abstract, interpretation.

JJ. P4. THE SMALLEST PERSONAL STEREO IN THE WORLD.

DOLBY N.R. AUTO-REVERSE. INNER EAR HEADPHONES. METAL TAPE FACILITY. RE-CHARGEABLE CADNICA BATTERY.
UP TO NINE HOURS CONTINUOUS PLAYING TIME. AVAILABLE IN RED, WHITE OR BLACK AND SMALLER THAN A CASSETTE CASE.

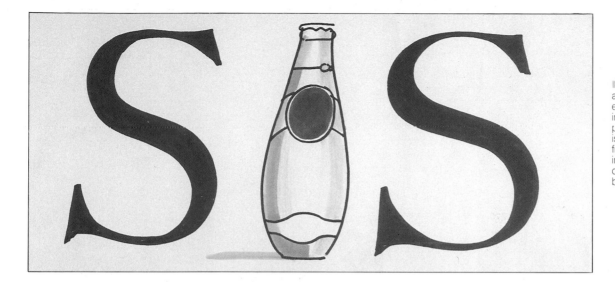

■ The clever idea of this advertisement needs little elaboration in its visual interpretation. Simplicity in its presentation is essential if the idea is to be free to communicate. The final print is extremely close to the initial visual, with only the shapes created by the graphic elements being refined over time.

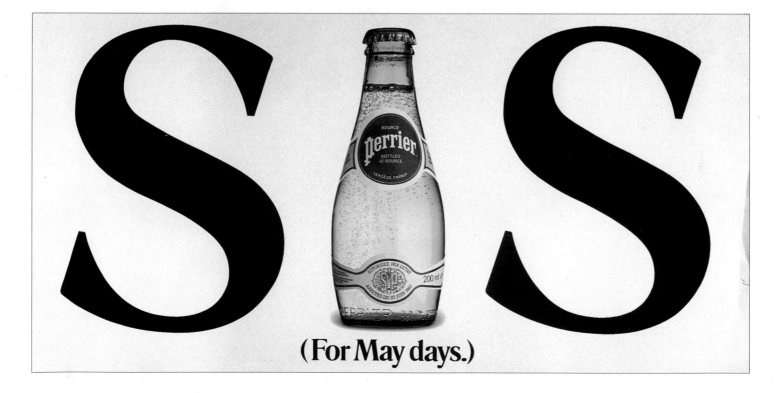

(For May days.)

The designer's initial thumbnail scamps for this beer label design were made simply and swiftly in pencil, and they represent the visual notations of an emerging idea. They are the designer's shorthand from which the visuals will eventually emerge.

Packaging

Top packaging design as a specialist area is the territory of a few highly sought-after studios that have, over the years, become known for their expertise in this work. It is rare to have an opportunity to view a packaging project through all of the stages of its development. Designers themselves do not always retain the visual plans of any one project, and you will often find that your visuals make their way to the client, never to be seen again. Having achieved his goal with a finished pack, the designer will have little use for the different stages of its development.

Package design is special in many ways: it demands ingenuity with materials, an understanding of the various mechanics involved in the production process, together with a highly developed feeling for three-dimensional graphic imagery and attention to the minutest detail. The

package designer is an engineer, a sculptor, an inventor of surface and a graphic design typographer of the greatest precision. In the early stages, the pack will be created with simple, flat drawings that will toy with an image that is relevant to the product. At this point the designer will be conscious of the product's position and status in the market place. He will also be aware of the client's need to sell more of his product than his nearest competitors. The concept must therefore be tailored to the consumer's need for new and refreshing product images. To achieve this, the designer may initially concentrate on a few aspects of the pack, possibly considering the volume of the pack and its surface qualities. The effects that can be reproduced with modern printing methods are almost infinite. Alternatively, the approach may be typographic or illustrative. Whatever the starting point, these elements will eventually be formulated into one package design.

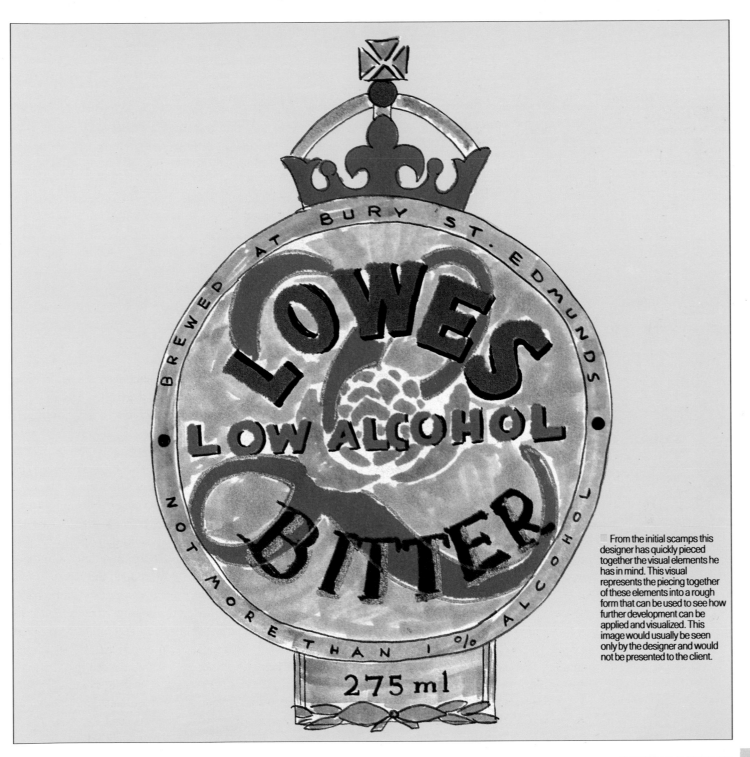

From the initial scamps this designer has quickly pieced together the visual elements he has in mind. This visual represents the piecing together of these elements into a rough form that can be used to see how further development can be applied and visualized. This image would usually be seen only by the designer and would not be presented to the client.

When the concept has emerged, some visuals showing the possible alternatives will be needed. The way in which these are generated and the materials that are to be used in this process will be defined by the nature of the concept. For instance, if the pack relies on a specialist, black marbled surface, this may need to be constructed three-dimensionally before the graphic detail can be realized. This should still be produced in the quickest possible way, perhaps by being applied to three surfaces only before more extensive visualization becomes necessary. One of the best ways of retaining a good creative momentum when visualizing packs is to be as precise but as economical as possible in the work that you prepare.

On these and the following pages you can see how these initial stages are visualized, and you can compare the differences in their approach to visualization of a variety of top designers. Their ways of tackling a problem and the emphasis they place on certain aspects of the design should be obvious. You should concentrate on being aware of how the design concept passes through its evolutionary stages. Different types of consumer product dictate the application of the most suitable rough visual process.

All of these packs have one thing in common. In the drawing and rendering of the rough visual, the visualizer has captured the intrinsic visual qualities of the product package as it will eventually be displayed. This has been achieved by a careful consideration of the drawing media that have been used. A detailed study of the visuals themselves will reveal the mystery of the methods and media involved in their creation.

■ These five visuals have been produced using a number of different techniques, from photocopies, to markers, to the Omnicrom process. They are the continuation of the ideas that we saw developing on the previous page. They represent visuals that could either be shown to the client as concept sheets or be used for the creation of a further stage of visual, which would be more finished. The design and its elements are now at an advanced stage.

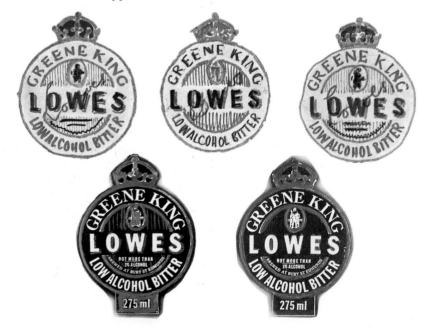

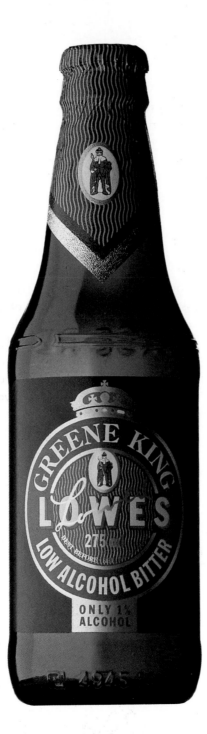

The conclusion of this project is seen in this final printed piece. You will note how all the various graphic elements have been reassembled, considered in great detail and brought together in this example of excellent package design. Note how the background elements of the label have been used for the crowner to reiterate the feel of the design. You should be able to see from this single project the complete thought process that lay behind the design.

The roughs shown here are just some of the huge number of ideas and visuals, produced using marker pens, that were made for this packaging project. The concept is embodied in these scamps, as you will see if you study the finished examples.

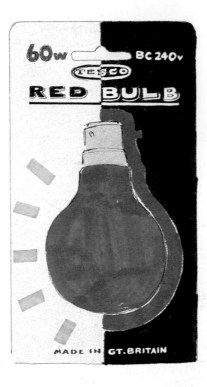

These final packs show how the linear outline of light, which represents the bulb, has been developed from the initial concept through to a unique series of packages.

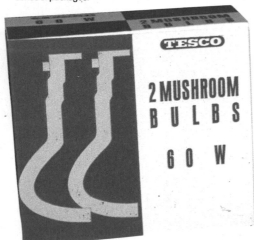

The display cards have extracted another element of the original concept. They have been developed in a more realistic format but still as bold, brilliant shapes.

In the final packs shown here, a combination of the bold, dynamic shapes and linear effects is placed on the iridescent background that was seen emerging in the initial scamp.

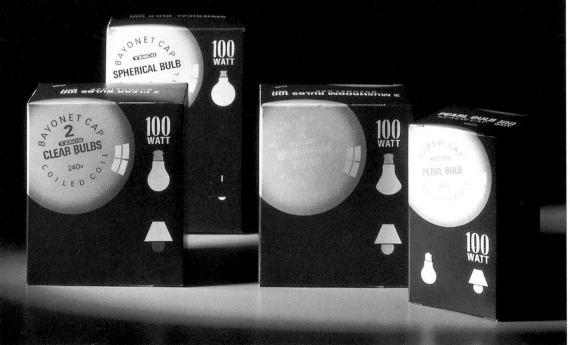

BEST OF ALL WORLDS.

Honeywell Bull offers corporate Canada strategic advantage on a number of fronts:

□ A superb team of systems development and integration specialists whose services are in demand around the world. Their role: to take the information requirements of an organization and knit them into an integrated system.

□ A full complement of mainframes, mid-frames, and minis—from the very fast and very large to the very small but very powerful—to suit a host of needs.

□ Highly sophisticated office automation. Plus networking based upon *open systems architecture*. Result: unparalleled capability and versatility in departmental systems.

□ The best and most comprehensive service network in the land, offering TotalCare™ for equipment from over one hundred vendors.

□ Unrivalled secure computing.

□ A hot new UNIX™-based platform with outstanding *built-in growth potential*. Enhanced by software houses with the expertise to create turnkey systems.

A truly international contender, Honeywell Bull stands out as the new world force in computers.

Honeywell Bull Limited, 155 Gordon Baker Road, North York, Ontario M2H 3P9 1-800-268-4144.
UNIX™ is a trademark of AT&T.

THE NEW WORLD FORCE IN COMPUTERS.

Honeywell Bull

■ You can see from the finished design how closely the overall concept has been followed, although you will note that the actual design elements have been moved around to create a new layout. When so much design space is available, togther with the added bonus of an abstract, textured background, new arrangements are easily found.

General design

Design consultancies produce visuals for all manner of design jobs, the designers involved often working as a team. In any single design consultancy there will be graphic designers with different levels of experience and seniority, and it is quite common for them to work collectively, with the juniors engaged in creating the visuals. Their energy is used to produce dozens of scamps from the concepts that have been discussed collectively. When sufficient alternatives have been produced, the expert eyes of the senior staff will begin to make the important decisions about the design's progress. From what has been produced, they are able to steer the work along a set route. Once again, the visual process will be continued as one or two of these drawings will be pushed nearer to the point where the client's brief is beginning to be fulfilled.

The designers themselves are likely to be capable of producing all the visual stages involved in any given project, although one of them may be better suited to the project in hand than the others. I point this out because the work produced in design consultancies, which are dealing with such a variety of projects, will rely on the strengths of different talents for different operations. Some designers will be heavily committed to typography; some may be particularly sensitive to the use of colour; others may prefer an illustrative approach. It is the role of the

HAIL THE NEW TITAN!

ckly and easily. The typographer's
ld be Typogs function is to convey a visual
ge quickly and easi The typographer's aim
ld be to aid easy le ility.

most reada typeface for a given pr
Typography's func on is to convey a visual
ge quickly and easi v The typographer's aim
ld be to aid easy leg ility. He can do this by
ng the most

Typogs function is to convey a visual
ge quickly and easily. The typographer's ai
ld be to aid easy legibilit He can do this by
Typography's fun on s t onvey a
ge quickly and easily.

ld be tasy legibility. He can d thi
ng the most readable typefa

raphy's function is to convey a visual
ge quickly and easily. The typographer
ld be to aid easy legibility. He can do th y
ng the most readable typeface for a g ven
Typography's function is to convey a visu
ge quickly

The easy legibility. He can do this by
Typography's function is to convey a visual
ge quickly and easily.

ld be to aid easy legibility. He can
ng the most readable typeface for a giver
Typography's function is to convey a visu
ge qui ly and easily. The typographer's aim
ld be to d easy legibility.

most readable typeface for a given
Typography's function is to convey

THE NEW WORLD
FORCE IN COMPUTERS

Honeywell Bull

senior designer to monitor his team in a business-like fashion so that he can extract the best work from each individual for the benefit both of the client and, ultimately, the consultancy.

■ The visual for this piece of graphics clearly defines, in precision marker, the illustrative content. The typographic headings, rendered in white gouache, accurately convey a message, while the body type, which is just unrelated words strung together, gives a visual feel to the copy. This matter can be stuck to an acetate sheet and laid over the visual so that a colour photocopy may be made for the presentation.

Every piece of print that you will see will have gone through some design process. The quality of that process should be obvious to you, but, although it is difficult to envisage the stages that have been covered in the production of this work, you should start to try to evaluate this work in visual terms. Look at a piece of company stationery and attempt to trace back through the steps involved in its creation. Try to image how the elements have been moved around within the space. Look carefully at the colours that have been chosen for this work and see if you agree with the end result. This process will develop your critical eye and improve your design awareness.

On this and the following pages you can see how a number of professionals have pursued a visual process. You will identify different styles and the use of different materials. Try to imagine how you might have worked on these designs. Are there other stages of development that could have enhanced the design? Test your own visual skill.

The final question you should pose is the vital one. Do you see the relationship between the visuals shown here and the finished pieces? Remember, it is the job of all concerned in the design process to have a picture of the work in a finished state. Even at the earliest stage, when the visual is nothing more than a series of rough marks on the scamp sheet, the person responsible for visualizing must be able to translate those marks into a mental picture of a finished piece.

■ Transfer lettering can sometimes be used in the visualizing process. You can rub down letter shapes to make your headings and sub-headings, and apply marker over the top of this and to the background to create a solid background colour. The transfer lettering can be removed with masking tape, leaving the heading appearing white out of the solid background. This visual makes use of this process, and colour has been introduced by tinting the white letters.

The printed leaflet shown here shows clearly how the visual acts as a brief for the final print. The graphics and the photography for this work, and their styling, were clearly established in the visual. All that remained to be finalized was the detail, and the artwork for the design was completed and the work printed.

December 17, 1983 Bradley Air Museum

POWERED**FLIGHT**DAY

This poster courtesy of Pratt & Whitney, a division of United Technologies

■ Although these two visuals are close to the final print, they have been rendered by hand. The main typographic headings have been drawn onto the surface of the visual or they have been applied photographically onto clear acetate and laid over the illustrative components. The illustrations are intended to convey the spirit of children's drawings but are highly contrived to suit the nature of this project.

POWERED **FLIGHT** DAY

December 17, 1983
Bradley Air Museum

This poster courtesy of Pratt & Whitney, a division of United Technologies

POWERED**FLIGHT**DAY

December 17, 1983
Bradley Air Museum

The final print shows how close the visuals were to what is printed, but you will note the subtle difference in actual type compared with the visualized type and the way the illustration has been redrawn – possibly many times. The advantage in having so few design elements is that it gives you time to experiment; a disadvantage can be that the smallest element needs to be precisely and exactly rendered.

This poster courtesy of Pratt & Whitney,
a division of United Technologies

THE 1988 SPRING/SUMMER COLLECTION FROM ALFRED
DUNHILL HAS BEEN INSPIRED BY THAT OASIS OF CALM,
THE BRITISH MARINA. ELEGANTLY CRAFTED SURF-WHITE
YACHTS SPORT SAILS OF BRETON RED, BURNISHED GOLD
AND EMERALD GREEN. THE RESONANT COLOURS OF SKY
AND SEA ARE MIRRORED IN SHADES OF TEAL, NAVY AND
ROYAL BLUE. SOFT SUMMER EVENING PASTELS REFLECT
HUES OF AQUAMARINE, SHELL PINK, SANDY BEIGE AND
OYSTER GREY. THE MARINA, A CLASSIC VENUE OF STYLE
AND TASTE. THE MARINA COLLECTION, CAREFREE WHEN
ACTIVE, EASY WHEN RELAXED, ASSURED WHEN FORMAL.

■ Roughs sometimes need to be presented only as a representation of the final work. This series of visuals for Dunhill shows how the visual suggests pieces of material while the front cover design indicates embossing. On the spreads showing material, some samples have been included with the design layout to give the client a more finished idea of the proposed elements. The same applies to the front cover visual, on which the lines shown form the basis of an embossed image.

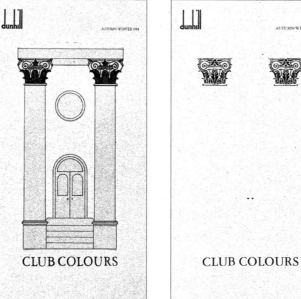

■ In the final print you will be able to discern how elements have been illustrated to resemble as closely as possible the surface texture of woven material. In the case of the front cover, the columns, window and doorway have been pressed out of the paper to create an embossed effect. When you create visuals of this kind, it is important to find subtle methods to describe technical production processes.

The Dunhill Suit. A Dunhill suit begins life only after the cloth is to be cut from has been selected from amongst the finest in the world and then undergone rigorous testing for wear and tear. Only then can the cloth be translated into a given style through the precious talents of dedicated designers and tailors. With a 'made to measure service', cutters work to a ⟨○⟩ whole series of precise measurements supplied directly from the customer to ensure a perfect fit. Stitched by the craftsman's hand, the Dunhill suit slowly takes shape with a sensitivity of touch that guarantees its durability and good looks. Painstaking patience at the final, pressing stage, ensures that every suit takes on the shape which will last as long as the garment itself. Only when every detail of the garment has been examined can the Dunhill label be added at the finishing touch.

Cutting for wear
Dunhill suit
Cutting for wear
Dunhill suit
Cutting for wear
Dunhill suit
Cutting for wear
Dunhill suit
Cutting for wear
Dunhill suit
Cutting for wear
Dunhill suit
Cutting for wear
Dunhill suit

■ These pages describe in visual terms the combined effect of the photography and the typographic layout. This visual has been produced using actual type, and the image to be photographed has been drawn to imply the style and elegance of the final photograph.

The Dunhill Suit. A Dunhill suit begins life only after the cloth has been selected from amongst the finest in the world and undergone rigorous testing for wearability. Only then can the material be translated into a given style through the talents of dedicated designers and tailors. With a 'made to measure' service, cutters work to a whole series of precise measurements supplied directly from the customer to ensure a perfect fit. Stitched by the craftsman's hand following the traditional process of natural canvas interlining, the Dunhill suit slowly takes shape with a sensitivity of touch that guarantees its durability and good looks. Painstaking patience at the final, pressing stage ensure that every suit takes on the shape which will be as long-lasting as the garment itself. Only when every detail of the garment has been examined can the Dunhill label be added as the finishing touch.

The removal of stains and general cleaning should be carried out only by a reputable dry-cleaning company. Keep your suit jacket on its original hanger and hang the trousers vertically to help retain their shape. Avoid high temperatures and humidity.

Whether in the high-pressured business environment of the city or the rich parts of rural England, Dunhill Colours line a sober, yet stems fine taste and elegance.

Dapper style is reflected in classics of cloth and colour. Sophistication runs and greens are highlighted by vivid cobalt and windows.

Away from the cities past the English heartland is a plenitude in shades of the brighter season. Toxic colour and deep crimson are reflected in fine tweeds and luxurious knitwear.

Traditional optimism elegance and colour reflects any class and personal openness in Dunhill Colours, the European Winter 1991 Collection from Alfred Dunhill.

■ You can see from the photograph of the suited man that all the elements of the line drawing have been retained, right down to the tie he is wearing. Photography will often redefine the best visual layout, but you can see here how the essence of the overall page spread has been retained in full.

Sedgwick Brochure Visual received 17 June

pale blue background

Wigmore Publicity
Contact Ali 555 4222
Roughs 23 June

Else Watercolour.
(a) mask out images first before laying in light Blue
mussels Reference book for Seaweeds.

Do they require Rainbow or brown Work 2 up.

Trout. paint Brown

Abolone → No ref for Abolone shells at Nat. Hist. Buy book.

Sea or River? (b) Looks more like Sea Bream but there are many varieties

Bream Oysters (c) are edible crabs pink/lilac they are cooked

prawns

Turbot

edible seaweeds

Visit Natural History M. Tube of Cad red W/C while retaining the central area for the type the fish etc could relate better

The light Blue setting slightly Darker. note these prior publicity—

Illustrations

Most pieces of graphics will include some element of illustration. These works are either hand-drawn images, photographs or technically manipulated photographic images. In the initial stages they will be the overall responsibility of the designer or design team, for these illustrations are inseparable from the design concept and message, and they become a fundamental styling element in the work. Illustrations cross all the boundaries of the graphic design industry: you will find them used in advertising, magazines and book publishing, on packaging and, in fact, on any piece of promotional work. Indeed, you are likely to see an illustration whenever you pick up or refer to printed matter.

The illustrator's role could be described as that of an interpreter of the designer's visual ideas, although it is often the case that the designer exploits what he knows the illustrator is capable of producing. The designer will often have a range of preferred and current illustrators in mind when tackling a project, and the communication between the two professionals will further the concept through their cooperation and the interplay of their ideas.

There are times when the illustrator will be nothing more than an interpreter, with the freedom to exploit and develop his or her own visual territory. This will usually happen when the brief has been set by a client whose main experience and responsibility is editorial rather than visual. Working with this freedom enables the illustrator to become established in his own right. But whatever is to be the finished illustration, some visuals will have to be produced. The designer may expect to receive illustration artwork direct from the supplied visual – in other words, on these occasions the illustrator will be supplying what is known as a finished illustration, which will be used without alteration in the final printing.

Above you can see the initial idea for an illustration emerging. The components of the illustration are carefully placed by the designer to accommodate the typographic element. The style of illustration need not be clearly defined, although this project will call for a naturalistic style.

However, although the illustrator will produce the final work, he or she must also be capable of producing roughs, and alternative roughs, to show the client, and this process could form another stage in the design process. By this I mean that the designer/visualizer has the first attempt at the illustrative component even though this may be the merest hint of what is still to be produced. The illustrator will then be called upon to make this element of the project into a tailored piece to suit the work in hand.

From the designer's sketch a brief is prepared for the illustrator's final piece. You can compare the working drawings prepared by the designer with the finished artwork in its printed form and see how closely the illustrator has interpreted the initial thoughts.

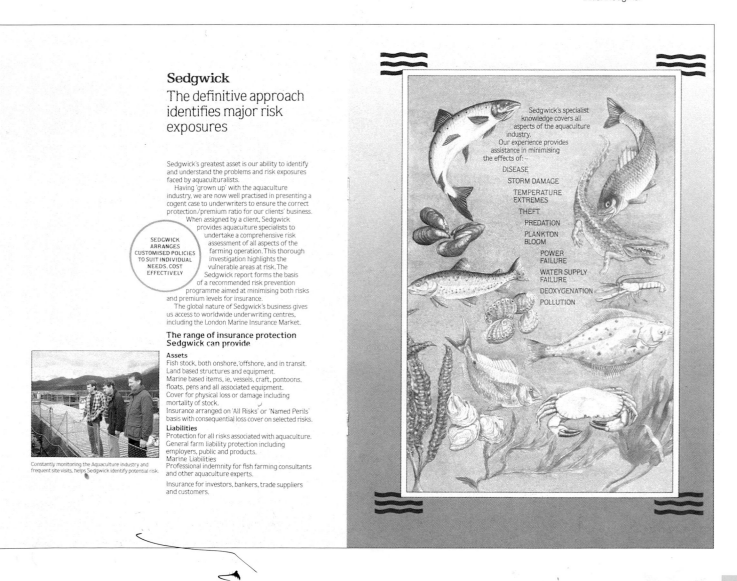

Sedgwick
The definitive approach identifies major risk exposures

Sedgwick's greatest asset is our ability to identify and understand the problems and risk exposures faced by aquaculturalists.

Having 'grown up' with the aquaculture industry, we are now well practised in presenting a cogent case to underwriters to ensure the correct protection/premium ratio for our clients' business.

When assigned by a client, Sedgwick provides aquaculture specialists to undertake a comprehensive risk assessment of all aspects of the farming operation. This thorough investigation highlights the vulnerable areas at risk. The Sedgwick report forms the basis of a recommended risk prevention programme aimed at minimising both risks and premium levels for insurance.

The global nature of Sedgwick's business gives us access to worldwide underwriting centres, including the London Marine Insurance Market.

SEDGWICK ARRANGES CUSTOMISED POLICIES TO SUIT INDIVIDUAL NEEDS, COST EFFECTIVELY

The range of insurance protection Sedgwick can provide

Assets
Fish stock, both onshore, offshore, and in transit.
Land based structures and equipment.
Marine based items, ie, vessels, craft, pontoons, floats, pens and all associated equipment.
Cover for physical loss or damage including mortality of stock.
Insurance arranged on 'All Risks' or 'Named Perils' basis with consequential loss cover on selected risks.

Liabilities
Protection for all risks associated with aquaculture.
General farm liability protection including employers, public and products.
Marine Liabilities
Professional indemnity for fish farming consultants and other aquaculture experts.

Insurance for investors, bankers, trade suppliers and customers.

Constantly monitoring the Aquaculture industry and frequent site visits, helps Sedgwick identify potential risk.

Sedgwick's specialist knowledge covers all aspects of the aquaculture industry.
Our experience provides assistance in minimising the effects of:—

DISEASE
STORM DAMAGE
TEMPERATURE EXTREMES
THEFT
PREDATION
PLANKTON BLOOM
POWER FAILURE
WATER SUPPLY FAILURE
DEOXYGENATION
POLLUTION

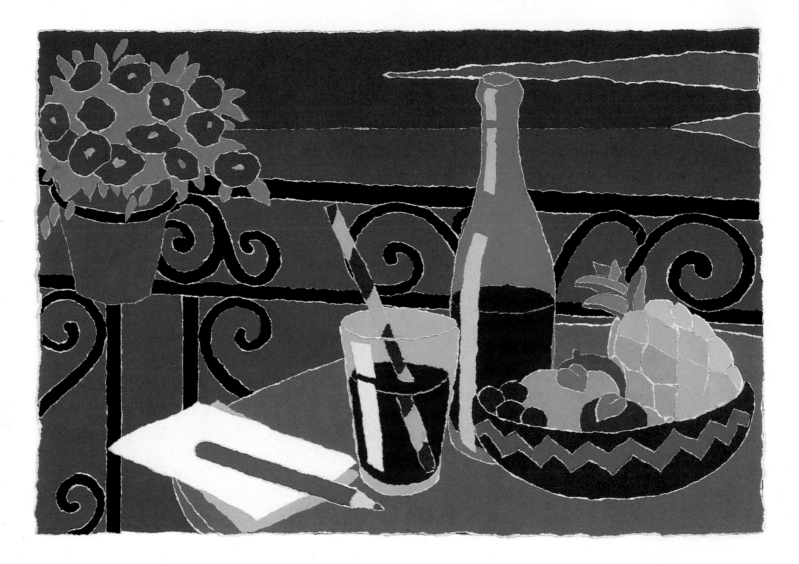

You will have understood by now that the illustrator is an independent professional who, more often than not, serves the industry in a freelance capacity. To demonstrate the link and working relationship between designer, editor and illustrator I have selected a number of different styles and approaches to the process of illustration which show the evolution of an illustrative idea from simple rough to printed image.

Remember that the illustrations used in the designs are often as complex in their stages of growth as those of any other design component. You should find the work displayed here a useful guide to the processes adopted. Compare the early roughs with the finished piece. Try to picture the stages as you would apply your own ideas and, finally, discover how the initial hint of style is implied throughout the rough visuals but manifests itself fully when it is printed.

In conclusion, we have seen in this book many areas of graphics whose styles and aspirations have varied. I have demonstrated some techniques that I hope you will find useful in your own work. I have discussed the various visual approaches employed in different areas of the industry, and you have seen these processes in action on the pages. Throughout these examples runs one common factor: all these rough visuals demonstrate the craft of expressing simple, visual ideas. If you always remember that accuracy and economy are the key to successful visualization, your whole approach will be professional and your expertise will be constantly in demand.

■ Illustrations can sometimes be used as the source for graphic design images. The elements from this simple children's illustration have been used as the basis for a logo, which can be seen at the bottom of the photograph. The elements have been retained to create an image that effectively communicates the world of children.

■ On the opposite page the illustration artwork has been produced using an interesting technique. The illustrator hand-tears each segment from coloured papers to create the image you see. The initial sketches are the only source of reference needed to formulate the composition. The finished piece is drawn carefully in pencil lines, and the paper is applied direct.

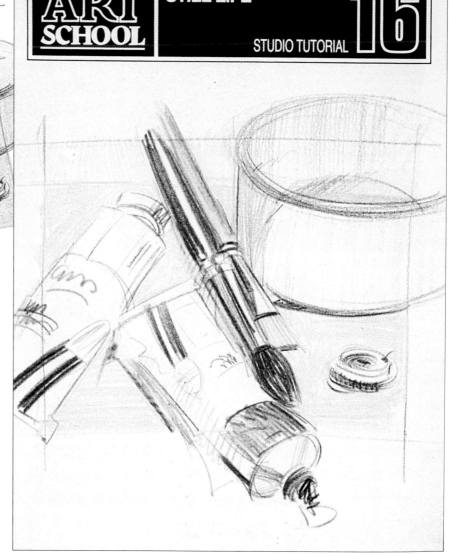

■ Here are a number of loose sketches that explore the possibility of using still life objects. These were initially done as roughs in coloured pencil, but they express the idea of still life drawing sufficiently clearly for the designer to select one as a finished illustration for print.

■ Illustrators' work should be looked at carefully to see how it can be adapted to other subject matters. This illustrator works in many styles. The drawings here were produced by using subtle overlaps of tissue paper, the final piece resulting from discussions between the designer and illustrator.

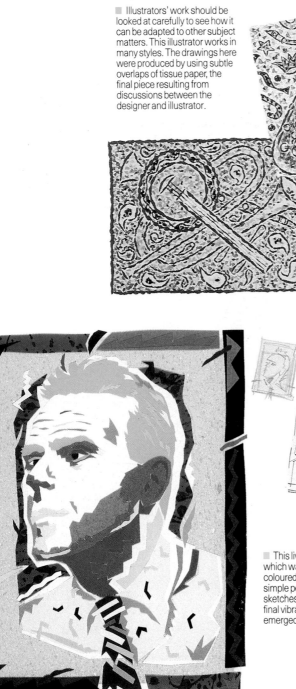

■ This lively image, which was produced from coloured papers, started as a simple pencil sketch. Various sketches were made before the final vibrant composition emerged.

■ The illustration above was produced by the same illustrator for a magazine cover. The technique used was scraperboard, and it is interesting to note that one illustrator is capable of working effectively in several styles.

As you can see from the notes surrounding the sketch on the opposite page, visual ideas and their development can be expressed in the form of written guidelines supporting the visual and its design. The reference to light in this sketch has been introduced to great effect in the finished illustration. The illustrator has followed the brief and captured the details of the fishes' anatomy and environment in a way that would delight the expert.

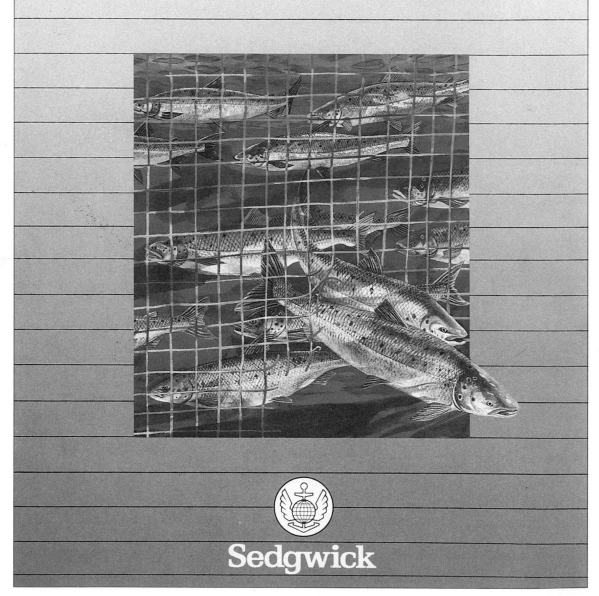

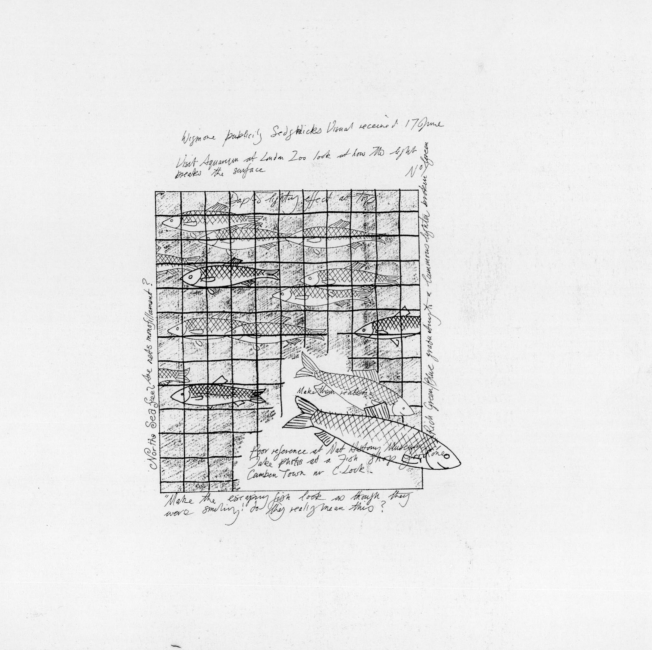

GLOSSARY

Adapts Different versions of a single advertisement which have been altered to fit the different sizes available in different publications but which retain the style of the original advertisement.

Airbrush A painting tool used for photo-retouching and gradated tones. It is a pen-shaped pressure gun propelled by compressed air, which mixes the paint with air to form a fine spray.

Angle-poise lamp A lamp used by designers which allows flexibility of direction of light over the work area.

Artwork Any graphic material which is of a high enough standard to be reproduced.

Billboard A large display area, usually upright, onto which advertising materials such as posters are attached.

Bleed-proof paper Marker ink can seep through paper and leave traces on the surface beneath. Although the effect of bleeding can be desirable, paper is available in bleed-proof and non bleed-proof to give choice to the designer/visualiser.

Body copy/text The main part of written matter as opposed to headings and sub-headings, etc.

Book jacket The printed sheet that wraps around the outside of a book carrying the title, author and any other information.

Cell A transparent, matt or gloss sheet made from cellulose and available in varying thicknesses. It can be used for any type of overlay, masks for airbrushing and in animation where individual sheets record any small change in a sequence of movement.

Collage A combination of a variety of components such as cut-outs, photographs and paint, to create a single image.

Colour proof The initial printed sheets which are run off enabling the printer, artist and client to check for registration and colour before the main run.

Composition The arrangement of the Graphic Design elements within the design area.

Concept The idea underlying a Graphic Design brief. This will arise either from the client direct or out of meetings to discuss the project.

Copywriter A writer whose work is specifically aimed at the promotion of products or services and which appears in advertisements, brochures, catalogues, etc.

Craft knife A knife used for cutting thick materials, such as board.

Cyan Shade of blue ink used in the four-colour process.

Day-glow Brand name for fluorescent paint, which is available either in liquid form or as Day-glow card – i.e. card that has been treated with the paint.

Die-stamping A printing process in which the image is in relief on the surface either in colour or without ink.

Direct mail A means of selling goods or services through advertising and using the postal services. The purchaser buys goods as a direct result of seeing the advertisement.

Direct response A means of selling goods or services through advertising and using the postal services. The purchaser sees an advertisement and is invited to enquire for further details.

Dummy rack A prototype that shows how a three-dimensional object, such as a book or package, will look by using the proposed materials but not necessarily showing all the graphics.

Elevation drawing A drawing in two dimensions showing each facet of a three-dimensional object.

Embossing A printing process where the image is raised above the surface by indenting the paper from the rear.

Fixative A clear, spray solution which is applied over an image, forming a protective coating. It prevents the image from smudging.

Four-colour process The process of reproducing full colour by separating the image into three primary colours – cyan, magenta and yellow – plus black. Each of the four colours is carried on a separate plate and when printed over each other, the effect of all the colours in the original are reproduced.

Gouache A form of watercolour favoured by designers which is opaque. It is created by the addition of precipitated chalk to the pigment which are then bound with gum arabic.

Gradation Blending of tones together in such a way as to make the tone change almost imperceptibly.

Grid In publishing, the sheets used to represent a double-page spread on which all the relevant measurements are printed, e.g. page size, margins, trim marks, etc. This enables the designer to place all the components accurately.

Hand lettering The technique of constructing letters with artificial aids and accurate measurements.

Illustration An image which has been drawn as opposed to being photographed.

Image The visual subject matter of a design, photograph or illustration.

Layout pad A specialist pad enabling the designer/visualiser to use marker pens freely and to overlay sheets for redrawing and improvement.

Letterhead Stationery that carries the name, address, telephone number and often a logo or design, of a business or individual.

Light box A piece of electrical equipment which

comprises a translucent screen which is lit from below to allow viewing of transparencies or to illuminate an image below another.

Livery Distinguishing graphics used and applied to forms of transport, uniforms etc., to represent the corporate image of the company or business. Usually an extension of the images used in the logo or stationery of the company.

Logo Initials or words cast as a single unit, usually for a company signature or trademark.

Lower case The small letters of a typeface as opposed to the capitals.

Magenta The standardized shade of red ink used in the four-colour process.

Magic markers A brand of marker used extensively in the advertising design industry. The broad nib is tooled in such a way as to give great flexibility of line and mark.

Mail order A means of selling goods or services without the purchaser having to go personally into the store to make the purchase. The purchaser chooses what he wishes to buy from a catalogue or brochure and the order is placed by post or telephone.

Margin The blank areas at the edges of a page that surround all the printed matter.

Markers Felt tipped pens of varying thicknesses used for drawing up rough visuals. The inks are usually either spirit based or water based.

Masking tape A tape which is coated in low-tack adhesive. This allows it to be used extensively by designers without the danger of surface damage.

Medium Refers to any type of colouring agent such as ink, paint, dye etc., that is used to cover a surface.

Mounting A general term referring to various methods of presenting visuals using a backing sheet of card or board and a protective overlay.

Mounting card Strong card onto which visuals are fixed for display.

'N'-ing A method of indicating lettering on initial rough visual drafts.

Omnicrom The brand name of a machine that colours designs. The machine only picks up the black from photocopies, so the image to be coloured must be copied in this way. The photocopy is sandwiched between a transfer sheet of the chosen colour with a paper backing. This then passes through rollers in the machine applying heat and pressure. When the transfer sheet is peeled off, the black photocopied image is left coloured.

Overlay A method of laying colours onto the surface over each other to create the desired effect. Different tones of a single colour can be overlaid to create gradations. Can also refer to transparent or translucent sheets laid over images or artwork.

Packaging A pack that is constructed and designed for an individual product.

PANTONE marker A brand of marker whose colours match the ranges of colours which can be produced by printers.

Photocopy An instant way of copying an original by various photographic techniques using mainly a machine known as a photocopier. As the quality and versatility of these machines improves, they are becoming a valuable design tool.

Point-of-sale advertising Display material for consumer goods, communicating information about products at the actual location where they are sold.

Pop-up Refers to any flat card or page that, when opened, various components physically stand up or spring out from the page. This technique is not cheap and involves a specialist cardboard engineer to achieve the correct results.

Poster A public communication device, displayed in public areas, most commonly found in railway stations, bus shelters and airports, or by the road.

Reverse out An image or lettering which appears white out of a solid background.

Rough visuals Initial sketches made prior to artwork. They are not as detailed as actual finished work, but echo the visual presence of a printed piece of work.

Sable brushes Paint brushes with natural sable bristles which allow the designer great flexibility of visual expression.

Scalpel A surgical instrument with a metal handle which holds an extremely sharp blade. Used for fine and delicate cutting work.

Scamp sheet A sheet of thumbnail sketches that is used during the early stages of the visualisation process.

Score To crease fold lines with a solid instrument and straight edge when constructing a three-dimensional object.

Scraperboard A board with a gesso surface which is inked and then scraped with a point or blade to give the effect of a white line engraving.

Shellac Lac which is melted into flakes which in turn are used to make varnish. Lac itself is a resinous substance secreted on trees by the lac insect.

Silk screen printing A method of printing where the image is formed photographically on a screen (originally made of silk) or by a cut stencil that adheres to the fabric of the screen. The ink is then forced through the screen and onto the surface.

Spray booth A box structure within which you can apply spray glue to items to be fixed without damaging the surrounding area and without being inadvertently affected by draughts or breezes. Can also be used for spraying aerosol paints.

Stencil A sheet from which images have been cut. The images are then reproduced by painting or drawing

through the holes.

Stippling A technique for creating texture by a series of tiny dots applied by hand.

Storyboard Used to show how a filmed sequence will look by using a series of illustrations rather like a comic strip.

Swatch Colour specimens against which inks and other materials can be matched. Usually available in book form, but you can create your own references on your layout pad.

Thumbnail sketch Very rough, small and quick initial sketch that is used to work out an idea.

Tint A faint colour often used as a background before printing.

Tone The varying shades of a single colour.

Tracing paper A translucent paper that can be placed over an image so it can be seen clearly, allowing the designer/visualiser to follow the outline in pencil or pen onto the tracing paper.

Typeface Term used to describe all the various styles of lettering available in typesetting.

Typesetting The assembly of type for printing by hand, machine or photography.

Type sheets Pre-printed sheets showing a variety of typefaces which are then used by designers for reference when choosing suitable faces.

Typography The process and specialised art of arranging printed matter using type.

Upper case The capital letters of a typeface or lettering.

Visualiser The visualiser gives visual form to an initial idea. He or she translates ideas into graphic terms.

Wash A watercolour or ink that has been diluted so that, when it is spread over a surface, it is very transparent.

Watercolour A coloured medium that is mixed with water and has a transparent quality.

Work up To add to and develop an initial sketch or drawing to produce the desired effect.

Yellow The third colour in the four-colour process.

INDEX

Page numbers in *italic* refer to the illustrations

A

acetates, 10
adapts, 80
advertising, 110-12, *110-15*
 billboards, 72, *72-3*
 direct mail, 76
 direct response, 76, *76*
 magazines, 80, *81*
 mail order, 76-7, 77
 point-of-sale, 74-5, *74-5*
 posters, 72, *72-3*
 press, 80, *81*
 storyboards, 78, *79*
 visualizers, 70-1, *71*
airbrushes, 9, 18
alternative layouts, 54-6, *54-7*
angle-poise lamps, 7, 12, *13*
art directors, 70, 78
art editors, 90
artwork, 62, *62-9*, 66

B

billboards, 72, *72-3*
black and white photographs, 40, *41*
blades, scalpel, *9*
bleach, on ink, 44, *45*
bleed-proof paper, 10, *10-11*, 12
blending colours, 20, 26
boards, mounting, 10, *10-11*
body copy, 30, *31*, 34, 36
book jackets, 90, *90-1*
books, 90, *90-1*
brochures, 77, 96-7, *96-8*
brushes, sable, 8, *9*

C

carbon paper, 10, 14, *15*
card, mounting, 10, *10-11*
cartons, outer packaging, 86, *86-7*
cartridge paper, 10, *10-11*, 14
catalogues, mail order, 77
chairs, 7
children's books, *53*, 90
children's illustrations, *106*, *126*, *133*
clients, 108-9
collage, 20, 56, *62*, *63*, 97
coloured papers, 10, *10-11*, 14
coloured pencils, 8, *9*, 18, *19*
colours:
 artwork, 62
 blending, 20, 26
 choosing, 6, 26, *26-7*
 colour visuals, 66, *66-9*
 computers, 109
 costs, 62
 lettering, 38, *38-9*
 magazine publishing, *92*, 93
 markers, 7, 8, 16
 in newspapers, 94
 overlays, 20, *20-1*
 PANTONE colour system, 66, *67*
 photocopying, 56
 photographs, 42, *42-3*
 press advertising, 80
 testing, 12, *13*
 texture, 26
 three-dimensional visuals, 84, *84*
commercials, television, 78, *79*
companies:
 livery, 103
 logos, *96*, 100, *101-2*, 103, *133*
 stationery, 103, *103*, 124

compasses, 8
computer graphics, 19, *91*, 109
concertina folds, *22*
containers:
 dummy packs, 88, *88-9*
 outer packaging, 86, *86-7*
 three-dimensional visuals, 84, *84-5*
 two-dimensional visuals, 82, *83*
copywriters, 70, 78
corporate images:
 livery, 103
 logos, *96*, 100, *101-2*, 103, *133*
 stationery, 103, *103*, 124
costs, 108
 illustrations, 104
 printing, 62
 visualizing, 24
coupons, direct response advertising, 76, *76*
cow gum, *9*
craft knives, 8, 12

D

design concept:
 advertising, 110
 magazines, 92
 packaging, 82
design consultancy companies, 70-1, 122
direct mail, 76
direct response, 76, *76*
displays:
 display cards, *121*
 point-of-sale advertising, 74-5, *74-5*
 rough visuals, 10, 14, *14-15*
drawing boards, 7, 8
dummy packs, 88, *88-9*
Dunhill, *128*
dust covers, 10

E

embossing, *128*
equipment *see* materials
erasers, 8, *9*
Erté, *51*

F

fibre pens, 30
finished rough visuals, 60, *60-1*
fixatives, 9
flat artwork, 66, *66-9*
flat plans, dummy packs, *89*
folds, formats, *22*
'Freepost', 77

G

gatefolds, *22*
general design visualization, 122-4, *122-9*
 books, 90, *90-1*
 brochures, 96-7, *96-8*
 leaflets, 96-7, *96-9*, 125
 logos, *96*, 100, *101-2*, 103, *133*
 magazines, 92-3, *92-3*
 newsletters, 96-7, *98*
 newspapers, 94, *94-5*
glue, spray, 8, *9*, 14
gouache, 8, 9, *9*, 12, 18, *18*, 34, *35*
gouache-resist process, *45*
graduated colours, 20, *20-1*
grids:
 books, 90
 magazines, 93

H

headings:
 newspapers, 94
 rendering lettering, 30
 'screamers', 76
 transfer lettering, *124*
 working up rough visuals, 48

I

illustrations, 6, 104, *104-7*, 130-3, *130-7*
 children's, *106, 126, 133*
 costs, 104
 rendering in rough form, 44, *44-5*
 style, 104
 visuals, *71*
 working up rough visuals, 50, *50-3*, 52
 see also photographs
illustrators, 48, 50, 90, 104, 130-2
imaginative lettering, 36, *36-7*
inks, 9, *9*, 18
 bleach on, 44, *45*
 gouache-resist process, *45*
 PANTONE colour system, 66, *67*
 scraperboard, 104, *107*
 silk-screen printing, 75
invisible tape, *9*

K

knives, craft, 8, 12

L

labels, *116, 119*
 packaging visuals, 82, *83*, 84
landscape folds, *22*
layout pads, 7
layout paper, 10, *10-11*, 12
layouts:
 magazines, *92-3*, 93
 newspaper, 94, *94-5*
leaflets, 96-7, *96-9, 125*
 format, 22, *22*
legibility, 38
letterheads, 103, *103*
lettering:
 costs, 62
 imaginative, 36, *36-7*
indicating, 28, *28-9*
rendering, 32, *32-5*, 34
rendering with colour, 38, *38-9*
spacing, *30*
transfer, *124*
light boxes, 9, *9*
lighter fuel, 9, *9*
lighting, 7, 12, *13*
line drawings, 104, *105, 106*
liner pens, 8, *9*
linocuts, *44*, 104
livery, 103
logos *96*, 100, *101-2*, 103, *133*

M

magazines:
 advertising, 80, *81*
 layouts, 92-3, *92-3*
Magic Markers, 8-9, 16
magic tape, *9*
mail order, 76-7, *77*
markers, 7, 8-9, *9*
 advertising visualizers, 70
 bleeding, 10
 fine line, *9*
 overlays, 20, *20-1*
 rendering black and white photographs, 40, *41*
 rendering colour photographs, 42, *42-3*
 sharpening, *13*
 testing, 12, *13*
 thumbnail sketches, 24, *24-7*, 26
 using, 16, *16-17*
masking tape, 8, *9*, 16, *17*
materials, 7, 8, 9, *9*
 coloured pencils, 18, *19*
 inks, 9, *9*, 18
 pastels, 9, *9*, 18, *18*
 Omnicrom process, 18-19
 surfaces, 10, *10-11*
 markers, 8-9, *9*
using, 12-16
watercolour, 18, *19*
mock-ups, dummy packs, 88, *88-9*
mounting, spray, 20, *21*
mounting rough visuals, 14, *14-15*, 60
mounts, 10

N

'N-ing', body copy, 30, *31*, 34
newsletters, 96-7, *98*
newspapers, 94, *94-5*
 advertising, 80
 photography, 94
nibs, markers, 8, 16

O

Omnicrom process, 18-19, *39*, 56, *57, 63, 101, 103*
outer packaging, 86, *86-7*
overlays, 20, *20-1*
 colour visuals, 66, *66-9*
 tissue paper, *57, 135*

P

packaging, 116-18, *116-21*
 dummy packs, 88, *88-9*
 outer packaging, 86, *86-7*
 three-dimensional visuals, 84, *84-5*
 two-dimensional visuals, 82, *83*
pads:
 layout, 7
 storyboard, 78
PANTONE colour system, 66, *67*
PANTONE markers, 8-9, *9*, 16
PANTONE papers, *10-11*
paper, 10
 bleed-proof, 10, *10-11*, 12
 carbon, 10, 14, *15*
 cartridge, 10, *10-11*, 14
coloured, 10, *10-11*, 14
layout, 10, *10-11*, 12
PANTONE, *10-11*
tracing, 10, *10-11*, 14, *15*
pastels, 9, *9*, 18, *18*
pencils, 8, *9*
 coloured, 18, *19*
 sharpening, 12, *13*
 water-soluble, 18, *19*
pens:
 fibre, 30
 liner, 8, *9*
 markers, 7, 8-9, *9*
photocopiers, 56, *56*
 Omnicrom process, 18-19, *39*, 56, *57, 63, 101, 103*
photographs, 6, *129*, 130
 in advertisements, *113*
 black and white, 40, *41*
 colour, 42, *42-3*
 in newspapers, 94, *95*
 reference material, 104
 re-touching, 62
 rough visuals, 46, *46-7*
 working up rough visuals, 48, *48-9*
 see also illustrations
plastic, clear adhesive, 10
point-of-sale advertising, 74-5, *74-5*
'Postage Paid' services, 77
posters, *71, 72*
presentation, scamps, 58, *58-9*
press advertising, 80, *81*
 direct mail, 76
printing:
 artwork, 62
 packaging visuals, 82
 PANTONE colour system, 66, *67*
professional visualization, 108-33
 advertising, 110-12, *110-15*

general design, 122-4, *122-9*
illustrations, 130-3, *130-7*
packaging, 116-18, *116-21*
proofs, colour, 66
publishing, books, 90, *90-1*

R

references, illustrations, 104
re-touching photographs, 62
reversing-out, 34, *35*
rough visuals:
 alternative layouts, 54, *54-7*, 56
 colour scamps, 26, *26-7*
 drawing up shapes, 22, *22-3*
 indicating lettering, 28, *28-9*
 indicating type, 30, *30-1*
 materials, 8-19, *8-19*
 overlays, 20, *20-1*
 rendering black and white photographs, 40, *40-1*
 rendering illustrations in rough form, 44, *44-5*
 rendering lettering, 32-8, *32-9*
 rendering photographs in colour, 42, *42-3*
 stages of presentation, 58-66, *58-69*
 thumbnail sketches, 24, *24-5*
 visuals of type and illustrations, 50, *50-3*, 52
 visuals of type and photographs, 46, *46-9*, 48
rulers, 8, *9*

S

sable brushes, 8, *9*
scalpel holders, *9*

scamp sheets, 7, 24
 choosing colours, 26, *26-7*
 coloured lettering, *39*
 indicating type, 30, *30-1*
 lettering, 28, *28-9*
 presentation, 58, *58-9*
 rendering black and white photographs, 40
scissors, 8
scrapbooks, 104
scraperboard, 104, *107*, *135*
'screamers', 76
sellotape, 8
set squares, 8, *9*
shapes:
 alternative layouts, 54, *54-5*
 drawing up, 22, *22-3*
shellac inks, 18
shops, point-of-sale advertising, 74-5, *74-5*
silk-screen printing, 75
sketches *see* thumbnail sketches
spacing, lettering, *30*
spirit-based markers, 7, 16, *17*
spray booths, 14, *14*
spray glue, 8, *9*, 14
spray mounting, 20, *21*
stationery, 103, *103*, 124
stencils, 44
stippling, 26
storyboards, 78, *79*
surfaces, 10, *10-11*

T

tape:
 magic, *9*
 masking, 8, *9*, 16, *17*
 sellotape, 8
techniques:
 advertising visualization, 70-80, *71-81*
 general design

visualization, 90-103, *90-103*
 packaging visuals, 82-8, *82-9*
television advertising, storyboards, 78, *79*
texture, 26, *128*
three-dimensional visuals, 84, *84-5*
 dummy packs, 88, *88-9*
thumbnail sketches:
 advertising visuals, *72*
 book design, 90
 colour, 26, *26-7*, 38
 leaflets, 96
 logos, *101*
 packaging, *83*, 116
 tones, 46, *46*
 using markers, 24, *24-5*
tissue paper overlays, *57*, *135*
title pages, books, *91*
tools, 8-9, *9*
tracing paper, 10, *10-11*, 14, *15*
 rendering lettering, 30, 32, 34
trade press advertising, 80
transfer lettering, *124*
two-dimensional visuals, packaging, 82, *83*
type, 6
 books, *91*
 indicating, 28, *28-9*, 30, *30-1*
 magazines, 92-3, *92*
 newsletters, 96
 newspapers, 94
 press advertising, 80
 rendering, 32, *32-5*, 34
 rough visuals, 46, *46-7*
 stationery, 103, *103*
 working up rough visuals, 48-52, *48-53*
typesheets, *28*, *31*

V

vehicles, livery, 103
visualizers:
 in advertising, 70-1, *71*
 design consultancy companies, 70-1
 function, 6
 relations with clients, 108
 skills, 6-7
 television advertising, 78

W

water-based markers, 7, 16, *17*
water-soluble pencils, 18, *19*
watercolour, 18, *19*
woodcuts, 44, *44*, 104
working environment, 7
worksheets, *23*, *36*

ACKNOWLEDGEMENTS

p7: Original design, Richard Bird and Associates, London; Illustrator of final posters, Paul Robinson; Client, London Underground; **p44-45:** John Scorey; **p46:** Bridgewater Associates; **p47:** *top*, The Horseman Cooke Design Agency; **p47:** *bottom*, Pentagram California US; Art Director/Designer, Kit Hinrichs; Client, MGM/UA Communications Corporation; **p48-49:** Pentagram, California, US; Art Director/Designer, Kit Hinrichs; Client, National Medical Enterprises Inc; **p50:** Stephen Tolfrey, Croydon College; **p51-52:** Bridgewater Associates; **p53:** *top*, Bridgewater Associates; **p54-57:** The Yellow Pencil Company; **p58-61:** Andrew McDowell, Croydon College; **p62:** EMAP Metro; Art Director, Caroline Grimshaw; **p63:** *top*, EMAP Metro; Art Director, Caroline Grimshaw; **p63:** *bottom*, QDOS; Client, International Mining Magazine; **p64-65:** EMAP Metro; Art Director, Caroline Grimshaw; **p66-67:** QDOS; Client, International Mining Magazine; **p68:** *left and bottom*, EMAP Metro; Art Director, Caroline Grimshaw; **p68:** *top right*, QDOS; Client, International Mining Magazine; **p69:** *left*, QDOS; Client, International Mining Magazine; **p69:** *right*, EMAP Metro; Art Director, Caroline Grimshaw; **p71:** *left*, Graham Dexter & David Smyth, Hounslow Borough College; **p71:** *centre*, Richard Bird & Associates, London; **p71:** *right*, The Yellow Pencil Company; **p72:** *top*, Gregory Cutshaw, Ohio, US; **p72:** *bottom*, Richard Bird & Associates, London; Client, London Underground; **p73:** Richard Bird & Associates, London; Client, London Underground; **p74:** *top*, QDOS; Client, Collier Campbell; **p74:** *bottom*, Richard Bird & Associates, London; **p75:** Richard Bird & Associates, London; **p76-77:** Alan Swann; **p78-81:** Graham Dexter & David Smyth, Hounslow Borough College; **p82-83:** The Horseman Cooke Design Agency; **p84:** Quarto Concept; **p85:** Lisa Hemus, Croydon College; **p86-87:** Quarto Concept; **p89:** *top right*, Lisa Hemus, Croydon College; **p90:** Alan Swann; **p91:** Quarto Publishing; **p92:** *top*, Bridgewater Associates; **p92:** *bottom*, Pentagram, California US; Designer, Kit Hinrichs; Client, McCall's Magazine; Art Director, Al Grossman; **p93:** John Scorey; **p94-95:** John Kimble, Daily Mirror; **p96:** *top*, Peter Laws for the Fine White Line Design Company; Client, Eurotunnel; **p96:** *bottom*, Chrissie and Alan Button; Client, Peltours Ltd; **p97:** Chrissie and Alan Button; Client, Peltours Ltd; **p98:** *right*, Pentagram, California US; Art Designer/Director, Kit Hinrichs; Client MGM/UA Communications Corporation; **p99:** Chrissie and Alan Button; Client, Dane Group; **p100-101:** The Small Back Room; Client, Hortiman Ltd; **p102-103:** The Yellow Pencil Company; **p104:** *left*, Chrissie and Alan Button; Client, Peltours Ltd; **p104:** *right*, The Yellow Pencil Company; **p105:** *top*, Agency, Grey Matter; Client, TailorMade Promotions; **p105:** *bottom left*, Sandra Bissoon; **p105:** *bottom right*, Jane Hartley; **p106:** Karen Tushingham; **p107:** Mick Armson; **p109:** Bob McKie, Tomcat Design Consultants; **p110-111:** *top*, Delaney, Fletcher, Delaney; Art Director, Steve Forrest; Copywriter, Simon Sylvester; Photographer, Paul Bevitt; **p111:** *bottom*, Abbott Mead Vickers SMS Ltd; Designer, Mike Turnbull; Client, Volvo Concessionaires Ltd; **p112-113:** Delaney Fletcher Delaney; Art Director, Steve Forrest; Copywriter, Simon Sylvester; Photographer, James Cotier; **p114:** Agency, Leo Burnett; Client, Sanyo; **p115;** Agency, Leo Burnett; Client, Perrier; **p116-121:** The Horseman Cooke Design Agency; **p122-123:** Lowe Case Associates Ltd, Toronto; Client, Honeywell Bull; **p124-125:** Ted Trott; Client, Letraset; **p126-127:** Appleton Design, Hartford, US; Art Director, Robert Appleton; Illustrators, Robert Appleton and Diana Minisa Appleton; Client, Pratt & Whitney Aircraft; **p128-129:** Sutton Cooper; Client, Dunhill; **p130-131:** David Eddington; **p132:** Mac McIntosh; **p133:** Tim Aston Design Ltd; Designer, Niall Henry; Client, Children's World; **p134:** Alan Swann; **p135:** *top & bottom right*, Shirley-Anne Barker; **p135:** *bottom left*, Mac McIntosh; **p136-137:** David Eddington.

Quarto would like to thank those companies who so willingly sent us transparencies and artwork, and who granted us clearance of their copyrights. Every effort has been made to obtain copyright clearance for the illustrations featured in this book, and we apologise if any omissions have been made.